Finders KEEPERS Quilts

A Rare Cache of Quilts From the 1900s

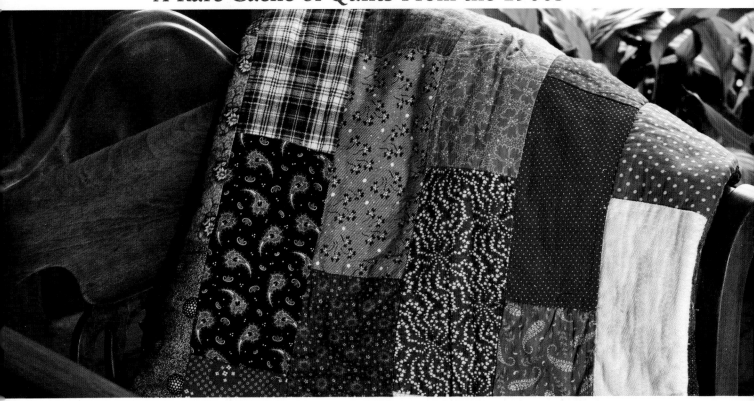

16 Projects - Historic, Reproduction & Modern Interpretations

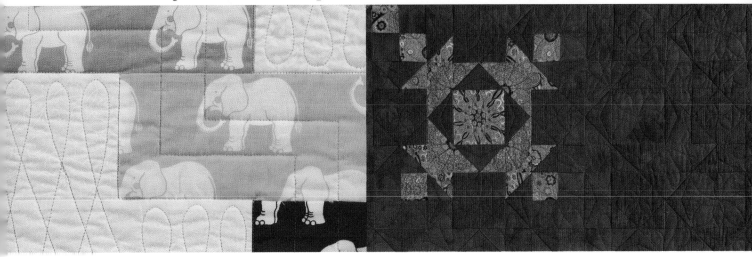

By Edie McGinnis with Susan Knapp

Finders KEEPERS Quilts

Text copyright 2015
by Edie McGinnis

Publisher: Amy Marson

Creative Director: Gailen Runge

Editor: Deborah Bauer

Technical Editor: Jane Miller

Cover/Book Designer: Kim Walsh

Photography: Aaron T. Leimkuehler

Illustration: Lon Eric Craven

Photo Editor: Jo Ann Groves

Library of Congress Cataloging-in-Publication Data
McGinnis, Edie with Knapp, Susan

Library of Congress Control Number: 2015952880

Finders Keepers Quilts – A Rare Cache of Quilts From the 1900s / Edie McGinnis with Susan Knapp

ISBN 978-1-61745-328-1 (soft cover)

Printed in the United States of America

10 9 8 7 6 5 4 3 2 1

Table of Contents

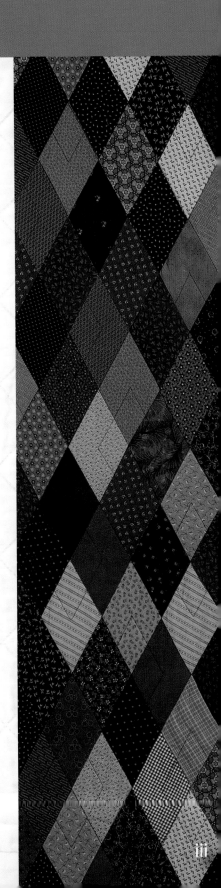

Acknowledgements

This book would never have come to fruition without the help of the following people.

Thanks go to Susan Knapp for allowing me to share the story of the quilts she found in the house she and her husband, Eric, bought. And to Sandra Amstutz, Susan's sister-in-law, for providing so much information and help with stitching quilts.

Susan and Sandra found the perfect house for the photo shoot. Nancy Squires, of Bloomfield, Iowa, graciously allowed us to use her home, which was built in 1907, the very same year that was found on one of the quilts. Thank you so much, Nancy!

Thanks to Koren Bell for donating the fabric for the Diamond quilt. Koren owns a quilt shop, Quilter's Nine Patch, in Elmira, Ontario, Canada.

My good friends Klonda Holt and Jane Kennedy lent me a hand with stitching and binding. Thank you so much!

A huge thank you to Robin Sackett for stitching the Prairie Rose Table Mat.

Shelly Pagliai of Wien, Missouri, is the talented quilter who made most of the quilts in this book look so stunning.

I am so lucky to have had Aaron Leimkuehler as the photographer on this project. His attention to detail and his patience are extraordinary. Lon Eric Craven is the talented artist who drew all the diagrams and templates. The photos were toned by Jo Ann Groves, who does the best job of making the photos match the color of the quilts. Kim Walsh is the book designer who made the pages look so warm and inviting.

Jane Miller is the math-minded person who always has my back when it comes to numbers. Deborah Bauer, my editor, is gifted at making me sound as though my thoughts are never muddled.

Thanks to all the people at C&T Publishing who saw to it that this book was printed.

Thank you to everyone who encouraged me and helped with this endeavor.

– Edie McGinnis

About the Author

Edie McGinnis began her career with The Kansas City Star in 1987. She was the associate editor of *Kansas City Star Quilts* and is the author of 18 books. She blogged every week on the *Kansas City Star* Quilts website. She has had several single patterns published and has written articles for quilting magazines Edie gives lectures and trunk shows on Kansas City Star quilt patterns, their history and the designers who worked at *The Star* in the early years; feedsacks; scrap quilts; and using precuts. She also combines workshops with lectures and trunk shows.

Found:
A Treasure Trove of Quilts

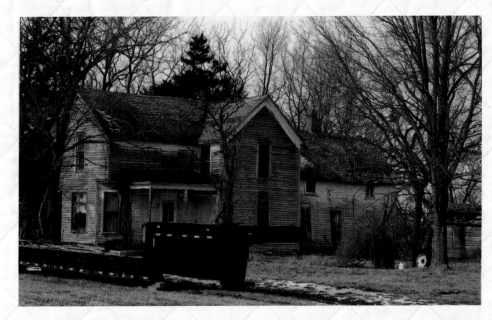

Drive through the countryside and you will occasionally spot one. A house, abandoned and bereft, with empty windows and sagging walls. It doesn't take much of an imagination to envision what a lovely home it must have been, to see that it had good bones before nature began to take its course. But the paint has vanished, leaving behind a weathered, gray patina.

Shingles are missing, and the roof is caving in here and there. Some of the windowpanes are broken, others are missing. It is clear that the people who used to live here have been gone for quite some time. And when they left, they took with them all the joy and laughter that used to bounce off of the walls.

The weeds have taken over the yard. Hollyhocks are still brave enough to bloom along the fence line, but all the other flowers that used to flourish around the porch have been crowded out.

We see houses like this in the Midwest. Not often, but frequently enough to pique a person's curiosity. I've never driven by one that I didn't want to stop and look inside. I wonder what kind of wallpaper had covered the walls, and I always want to know what kind of people lived there.

But most of all, I want to know what happened and why the house was left for nature to reclaim.

One such house was the Roulet family home and farm in Bloomfield, Iowa. When Eric and Susan Knapp bought it in 2012, they did so with the express intention of tearing the house down. It had been vacant since the mid-'70s and was in such a state of disrepair there could be no saving it.

They brought in a huge trash receptacle and parked it in front of the house. Eric was ready to start tearing it down the moment they closed on the deal. Susan wasn't quite so anxious.

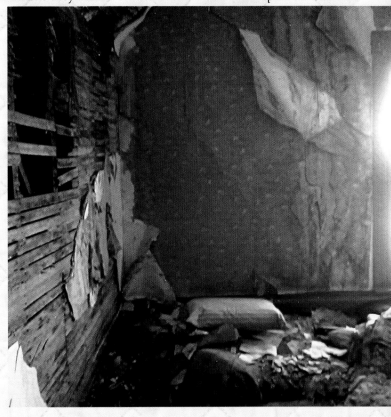

She was curious to see what, if anything, remained inside.

Susan donned a pair of tall rubber boots and pulled on rubber gloves before she waded into the knee-deep debris that littered the floors. She picked up a piece of crockery here, a pretty dish there, and other odds and ends that had been left behind.

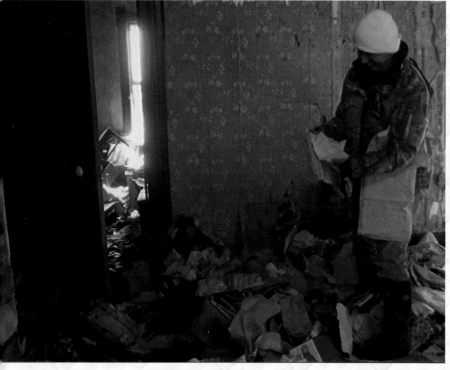

It was nearly dark when she called her sister-in-law Sandra Amstutz and excitedly told her that she had found a quilt. Sandra, a longtime avid quilter, drove over to take a look at the prize. It was a crazy quilt that still had the foundation papers in it. It was in fairly good shape but didn't smell the best.

Susan and Sandra couldn't go back in the house that evening, because it was too dark and the chances of falling through a hole in the floor too great.

Susan went back in the house the next day, again foraging through the mess. And Sandra got another phone call. This time, Susan told her that she had found a box of quilts. All were in good shape and had hardly been used.

After seeing the pristine condition of the quilts, the two knew they had to go through the entire house.

They went back the next day to see what other pieces might emerge from the mess. The roof leaked in every other room. Elsewhere, there were items that were wet and frozen in place. And the whole house smelled. Under one pile of rubble, they

found a chevron or braid quilt that had probably served as a carriage robe. The quilt had been made of lightweight wools and backed with a satiny type of fabric. It smelled so awful that they almost left it. But they couldn't quite manage to wal away from it.

Sandra washed it seven times using a gentle wash, and still the water failed to run clear. Afraid to continue wit the washing regime, she finally hung it over the bac railing of her porch, hoping the odor would disap- pear after the quilt was aired and left in the sunshir to dry.

They also found a redwork quilt that had been beautifully embroidered. Half of the blocks illustrat ed characters from the Bible, and those alternated with flower blocks. They are not sure who the origi nal designer of either series was, but it's a good gue the patterns might have been from McKim Studios. This quilt top was found under a large pillow that was on top of a mattress filled with wood shavings. The pillow was probably the only thing that saved i from water damage.

The next day, Susan and Sandra again went back into the house. Near a chimney, they discovered embroidered table toppers as well as several whole- cloth quilts. One of the quilts was a summer spread that had been embroidered with a ring of flowers in the cente The corners had been perfectly mitered. Other doilies and dresser scarves had also been tossed into the pile and had sus tained a great deal of water damage.

At the first opportunity, the two looked at the box of quilts. There were seven in the box, and all had been made within a 20-year span. The quilts had been made using a riot of scraps Clarets and cadet blues, double pinks and mourning grays, shirtings and purples, grays and blacks, browns and neons were all represented in the quilts. It was a virtual study of qui fabric from the early 1900s.

One quilt had a block that had been dated, and the pattern name had been inked on it as well. The block read, "Pieced 1908, Cedars of Lebanon, Quilted 1914." And while the quil- ter didn't put her name on her work, we at least know who sh was.

Her name was Fannie Roulet. She had married Sam Roulet o Oct. 11, 1920, in Pulaski, Iowa, when she was 37 years old.

time, the names of the people who had been admitted to the hospital were printed in the local newspaper so friends and neighbors would know to call.

Two of Fannie's sons took care of the house and the farm while she wasn't there. One day, they went to feed the dog and couldn't find it anywhere downstairs. When they checked upstairs, they found the bed had been stripped of every quilt Fannie had stored on it.

They never found the dog or the quilts.

Fannie was 102 when she died in 1985. She left behind a legacy of kindness and helpfulness to her friends and neighbors as well as perfect examples of quilts made in the early 1900s.

And the best part of the story is that the quilts landed in the hands of Susan Knapp, a woman who appreciates each stitch made by Fannie's hands. She cherishes each quilt but is eager to share her find with others. And we are all fortunate enough to be on the receiving end of Susan's generosity.

he couple had three sons, Dwight, Harvey and Samuel Junior. m died and left Fannie a widow in 1949.

Before Fannie married, she lived with her two sisters and a other. She was the only one who married. Until she married, e earned a little extra money for her quilting supplies by lping women in the area after the birth of their children.

After she married, she was a typical, hardworking farmwife. e raised chickens and a garden and tended her children. And she continued to quilt as me allowed.

As she finished a quilt, she placed it on a bed one of the upstairs bedrooms. One quilt was aced on top of another, each lying flat. Fannie anted to go upstairs to count the quilts and ked her daughter-in-law, Maxine, to help her ith the task. It was a blustery, cold winter day, Maxine talked her into waiting a bit, until e weather warmed up a bit. Maxine's best ess is that there were least 20 quilts on the ed.

Fannie had given her boys each a quilt and d made one for each of her grandchildren as ell.

It wasn't long after Maxine's visit that Fannie ll ill and was taken to the hospital. At that

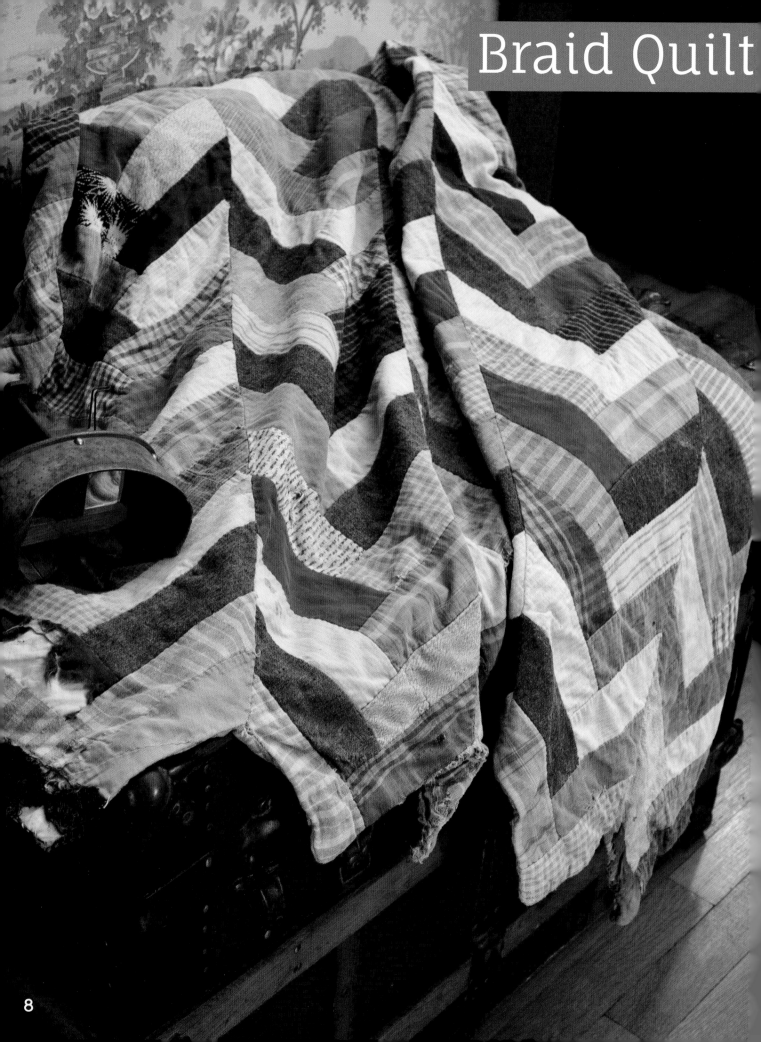

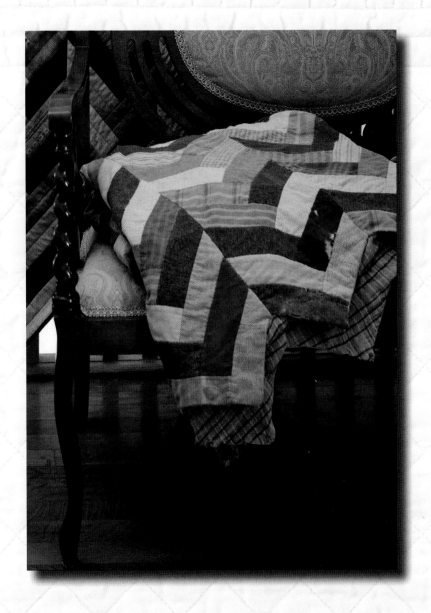

One of the quilts found in the house was this old carriage robe. It had been tossed on a mattress and a pillow thrown on top of it. Of the quilts found in the house, this one was in the worst shape.

Even though the quilt was tattered in places, its beauty could still be seen. It wasn't difficult to imagine what it must have looked like when it was fresh and new.

Braid Quilt

Quilt Size: Approximately 80" x 96" Finished

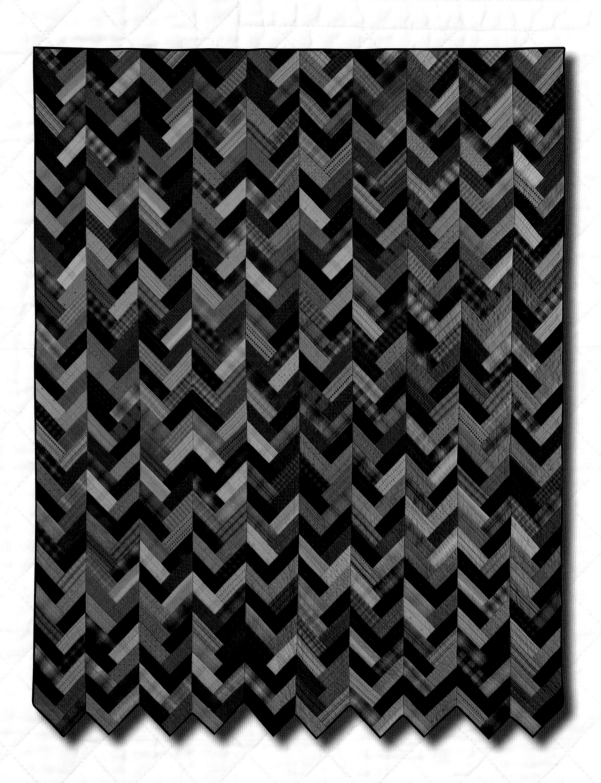

We reproduced the quilt using Daiwabo fabrics that included many yarn dyes that had slubs of wool running through the fabric. As well as texture, we used a wide assortment of plaids to reflect the look of the original quilt. The reproduction quilt was stitched by Sandra Amstutz, Bloomfield, Iowa, and quilted by Shelly Pagliai of Wien, Missouri.

Fabric Needed

Scraps to equal 10 1/2 yards
2/3 yard for binding

Note: We used 85 fat eighths from the Taupe Collection by Daiwabo for our quilt. Any homespuns, lightweight wools or cottons would be perfect fabric choices for this quilt, too.

Cutting Instructions

From the fat eighths or scraps or yardage, cut:

680 – 2 1/2" x 7 1/2" rectangles. If you are cutting from fat eighths, you will get 8 rectangles per piece by cutting vertically along the lengthwise straight of grain.

Each braid is made using 68 rectangles – 34 per side. You will need to make five A braids and 5 B braids. Sew the strips together, alternating sides as shown to make an A braid.

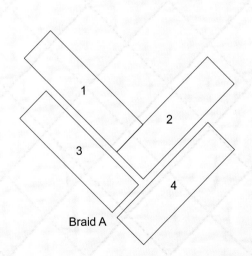

Braid A

Continue in this manner until you have sewn 68 rectangles together to make one A braid. Make five.

To make a B braid, sew the strips together, alternating sides as shown.

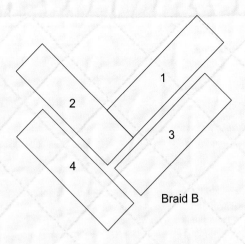

Braid B

Notice that the placement of the strips is reversed from the A braid. Sew 68 rectangles together to make one B braid. Make 5

When the sections are complete, trim the edges so they are straight.

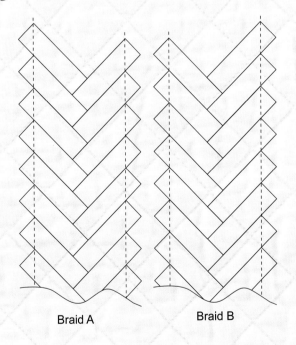

Braid A Braid B

Sew the strips together, alternating Braid A with Braid B.

Layer the quilt with backing and batting, and quilt as desired. After the quilt is quilted, trim the top of the quilt so it is straight across. The points should remain at the bottom of the quilt.

Before binding, staystitch around the outer edge of the quilt to stabilize the bias edges.

Braid Wall Hanging

Quilt Size: 31" x 40" Finished

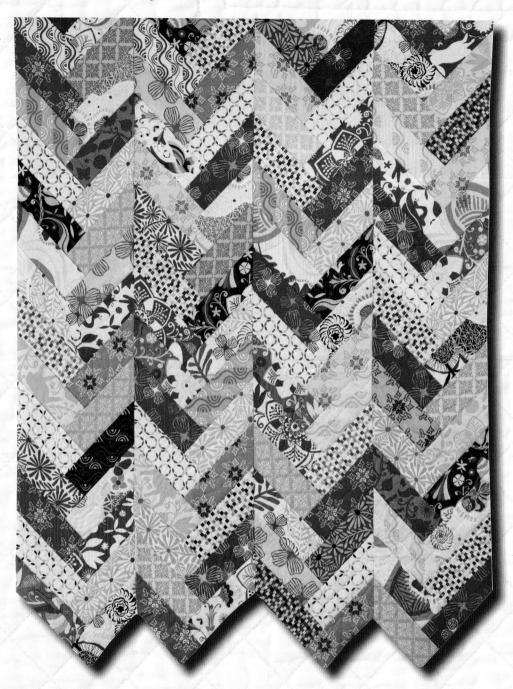

Do you find the thought of cutting all those 2 1/2" strips more than just a little daunting? There is another option available. Pick up a roll of 2 1/2" precuts at your nearest fabric shop. Cutting the length is a snap when you're working with the strips.

If the strips average 40", you can cut five 7 1/2" rectangles from each strip. Each roll should yield a total of 210 pieces.

Instead of binding the wall hanging, I faced it with the same fabric as the backing. Quilt made and quilted by Edie McGinnis, Kansas City, Missouri.

Fabric Needed

1 – 2 1/2" roll of precut strips

3/4 yard for facing

To make the wall hanging as shown, cut:

120 – 2 1/2" x 7 1/2" rectangles

Each braid is made by stitching 30 rectangles together, 15 per side.

Cut a strip wide enough to cover that area plus 2" x the width of the quilt.

Follow the directions for making braid A and braid B on page 11. Make two of each.

After trimming the edges so they are straight, sew the braids together, alternating braid A with braid B.

Layer the quilt with batting and backing, and quilt as desired.

After the quilt has been quilted, trim the top so the edge is straight across and square up the sides. The points at the bottom of the quilt can remain or, if you would prefer, you may trim them off.

Instead of binding the wall hanging, I faced it with the same fabric used for the backing. To face a quilt means to finish the edges without using a traditional binding.

The bottom pointed edge needs a wider strip than the top and sides.

Measure the quilt through the center from side to side. Make note of that measurement for the width.

Measure the quilt vertically along each side of the quilt. Make a note of that measurement for the length.

Cut one strip 2" x the width of the quilt. This will go on the top of the wall hanging.

Whole width

Cut two strips 2" x the length of quilt. You need one for each side of the quilt.

Measure the depth of the points on the bottom of the quilt. Cut a strip wide enough to cover that area plus 2" x the width of the quilt.

Press 1/4" under along one side of the length of the top strip. Pin the raw edge of strip to the front of the quilt with right sides facing. Sew in place using a 1/4" seam allowance. Press the top of the quilt and the strip to the reverse side of the quilt. Pin, then whipstitch the turned edge in place by hand.

Press 1/4" under along one side of the length of the bottom strip. Pin the raw edge to the front of the quilt. Sew the strip in place using a 1/4" seam allowance. Stitch around the pointed edges, then trim. Press the bottom of the quilt and the strip to the reverse side of the quilt. Pin, then whipstitch the turned edge in place by hand.

Press 1/4" under along one edge of each of the side strips. Turn under 1/4" at the very top and the bottom of each of the strips as well. Pin the raw edge of each strip to the front of the quilt with right sides facing. Stitch in place, using a 1/4" seam allowance.

Press the side of the quilt and the strip to the reverse side of the quilt. Pin, then whipstitch the turned edge in place by hand.

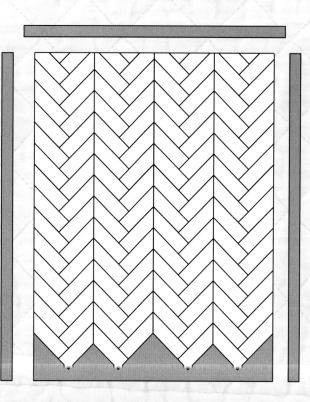

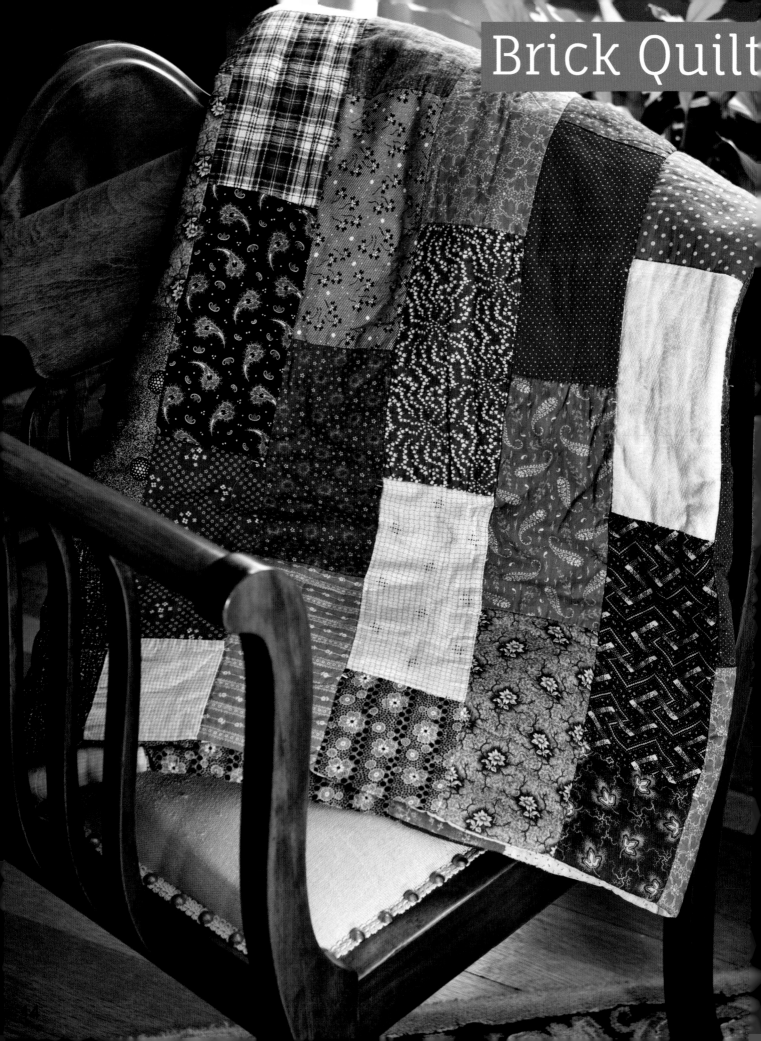

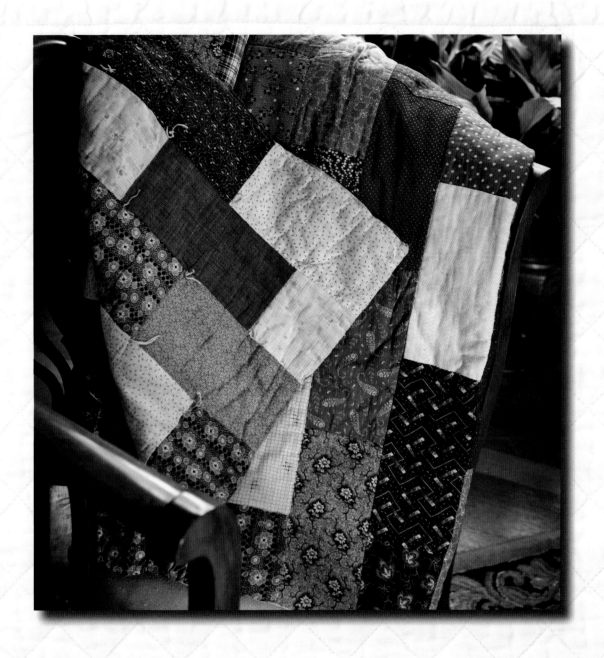

The original quilt Susan found in the house is reversible and is tied where the corners of each block meet. When the front and back is examined carefully, Fanny's expertise as a quilter is clear. The corner of each rectangle on the front matches perfectly with the corner of each rectangle on the back of the quilt.

Brick Quilt

Quilt Size: 90" x 94 1/2" Finished

Block Size: 3 1/2" x 7 1/2" Finished

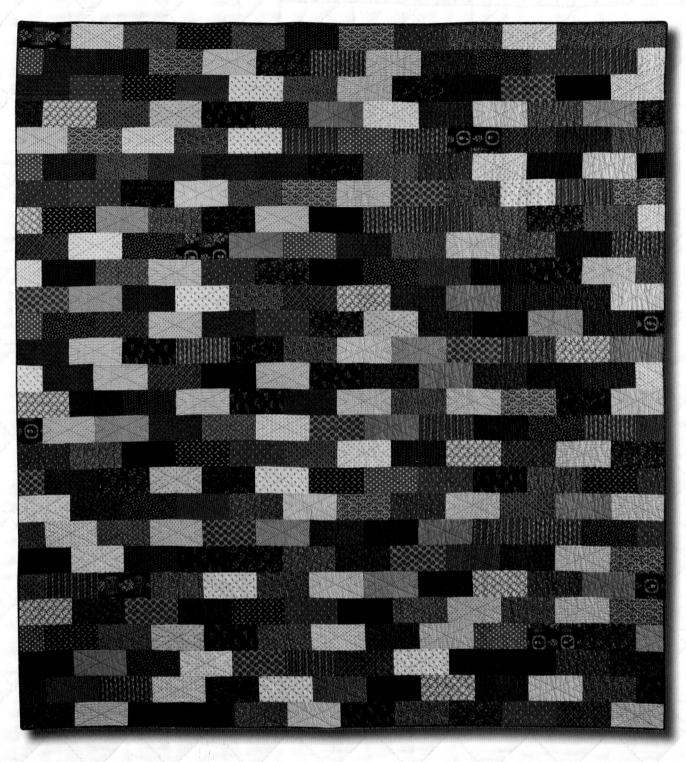

Our quilt uses early 1900s reproduction fabrics. We used a wide selection of colors and prints, ranging from mourning prints to double pinks and shirtings to achieve the same scrappy look as the original. Quilt made by Susan Knapp, Bloomfield, Iowa, and quilted by Shelly Pagliai, Wein, Missouri.

Fabric Needed

34 – Assorted 1/4 yard cuts across the width of the fabric
2/3 yard for binding

Cutting Instructions

From the assorted fabrics, cut:

311 – 4" x 8" rectangles.
26 – 4" x 4 1/4" rectangles (half blocks)

To Make the Quilt

Sew 12 rectangles end-to-end to make a row. Make 14.

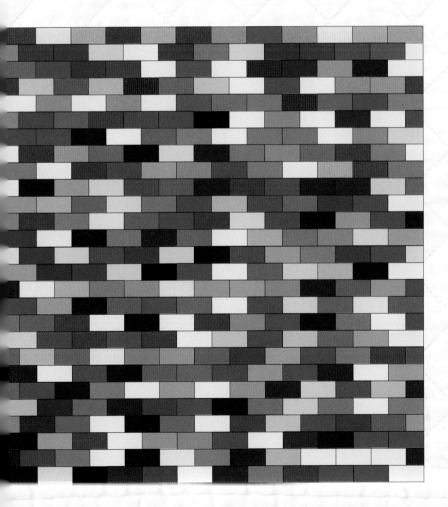

Sew 11 rectangles end-to-end, and add a half rectangle on each end to make the alternating rows. Make 13.

Sew the rows together. The first row should begin with a strip that starts with a full rectangle. The next row should begin with a strip that starts with a half block. Alternate the rows. The final row should begin with a full rectangle. Refer to the photo, if necessary.

Brick Quilt

Quilt Size: 60" x 60" Finished

Block Size: 3 1/2" x 7 1/2" Finished

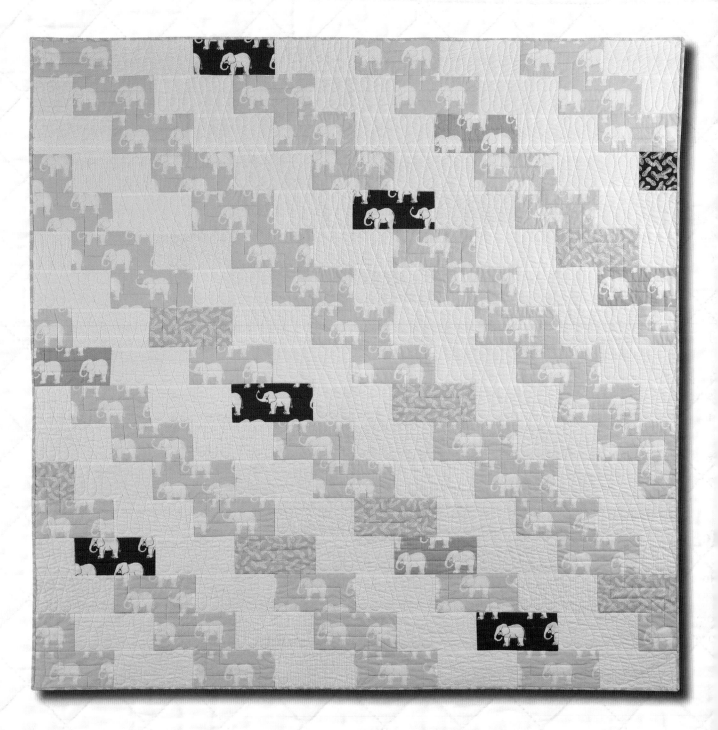

I used a fabric line called Trunk Show, Another Point of View by Windham for this version of the Brick Quilt. The fabric line features elephants on parade, big top circus tent diamonds and peanuts in the shell.

This fabric brings a bright cheeriness to the quilt and adds a bit of whimsy to any room. Quilt made by Edie McGinnis, Kansas City, Missouri, and quilted by Shelly Pagliai, Wein, Missouri.

Fabric Needed

7 – 1/4 yard cuts of different white on white prints or enough whites to equal 1 3/4 yards

1 3/4 yards lime green print (elephants)

1 fat quarter of another lime green (peanuts)

1 fat quarter red (elephants and, if you like, a scrap of peanut fabric)

1 fat quarter blue (elephants)

5/8 yard for binding

Cutting Instructions

From the white fabrics, cut:

54 - 4" x 8" rectangles

8 – 4" x 4 1/2" rectangles

From the lime green print yardage, cut:

49 – 4" x 8" rectangles

6 – 4" x 4 1/4" rectangles

From the lime green print fat quarter, cut:

6 – 4" x 8" rectangles

1 – 4" x 4 1/4" rectangle

From the red print fat quarter, cut:

5 – 4" x 8" rectangles

1 – 4" x 4 1/4" rectangle

From the blue print fat quarter, cut:

4 – 4" x 8" rectangles

To Make the Quilt

Note: Refer to the diagram for color placement.

Sew 8 rectangles end to end to make a row. Begin with a colored rectangle, and alternate with a white rectangle. Make 5 rows that begin with a colored rectangle.

Make 4 rows in the same manner, but begin with a white rectangle.

Make 4 rows by sewing 6 rectangles together end-to-end, beginning with a white rectangle. Add a colored half-rectangle to each end of the row.

Make 4 rows by sewing 6 rectangles together end-to-end, beginning with a colored rectangle. Add a white half-rectangle to each end of the row.

Refer to the diagram below, and sew the rows together.

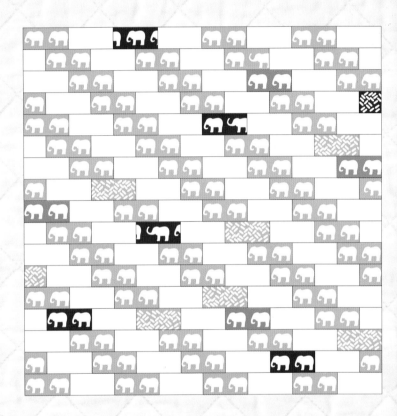

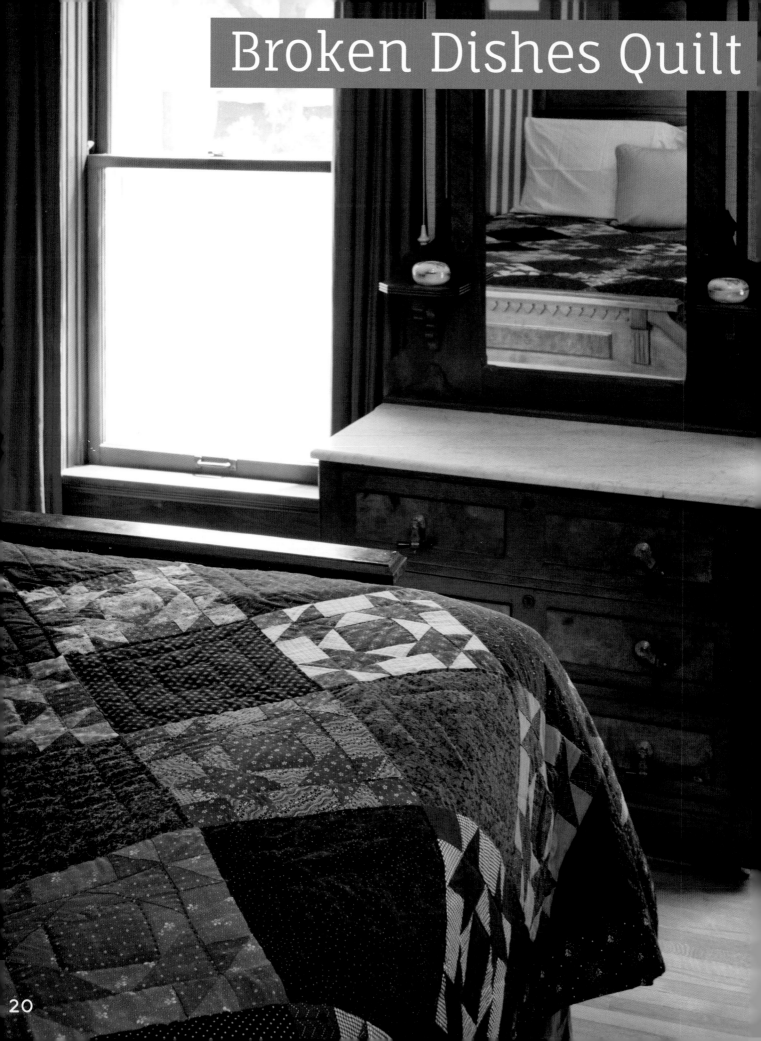

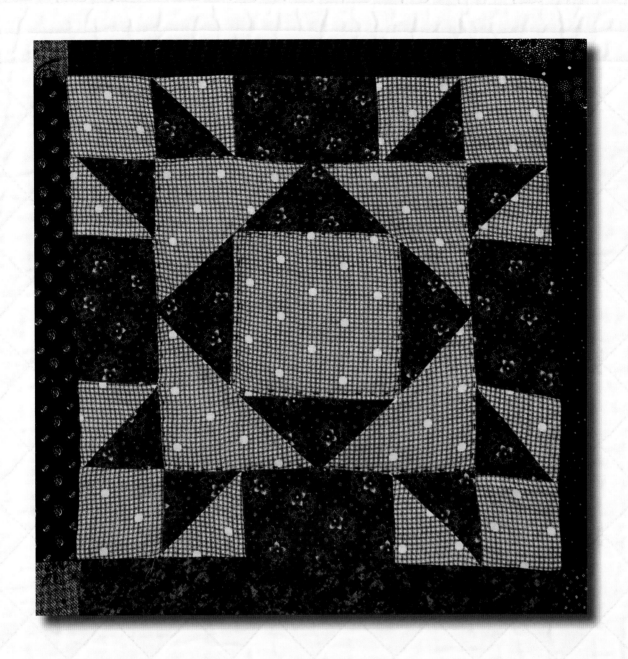

The blocks for this quilt were found in the house. They had not been sewn together, and one block had been made a bit differently from the others. The pieces used were all the same, but the light fabrics had traded places with the darks. Sandra Amstutz of Bloomfield, Iowa, stitched the blocks together and quilted it by hand.

Broken Dishes

Quilt Size: 74" x 91" Finished

Block Size: 12" Finished

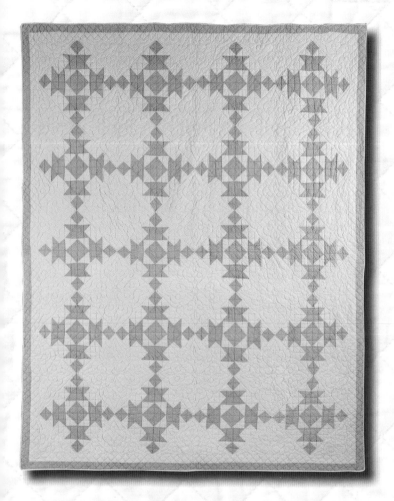

The appearance of the quilt changes drastically when the blocks are set on point and light colors used. Antique quilt from the collection of Edie McGinnis, Kansas City; maker and quilter unknown.

Fabric Needed

2 3/4 yards pink
5 yards white
2/3 yard for binding

Cutting Instructions

From the pink fabric, cut:

80 – 2 1/2" squares (A)
80 – 2 7/8" squares (B) – Cut each square from corner to corner once on the diagonal.
40 – 4 7/8" squares (D) – Cut each square from corner to corner once on the diagonal.
20 – 4 1/2" squares (E)
9 – 2" strips for the outer border

From the white fabric, cut:

80 – 2 7/8" squares (B) – Cut each square from corner to corner once on the diagonal.
80 – 2 1/2" x 4 1/2" rectangles (C)
20 – 5 1/4" squares (F) – Cut each square from corner to corner twice on the diagonal.
12 – 12 1/2" squares for setting squares
2 – 9 3/8" squares – Cut each square once on the diagonal to make the corner setting triangles.
4 – 18 1/4" squares – Cut each square from corner to corner twice on the diagonal to make the side setting triangles. You will have 2 triangles left over for another project.
9 – 2" x WOF strips for the inner border

To Make Each Block

Begin the center of the block by sewing a white F triangle to each side of the center pink E square.

Add a pink D triangle to each corner of the center unit. Set aside for the moment.

Sew a pink B triangle to a white B triangle to make a half-square triangle unit. Make 8.

Sew a pink and white half-square triangle unit to each end of a cream C rectangle. Make 4 BC units. Add a pink A square to either end of two of the BC units.

Sew a BC unit to either side of the center unit. To complete the block, add an ABCA unit to the top and bottom of the block as shown.

Make 20 blocks.

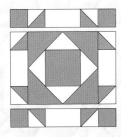

Follow the diagram below, and sew the blocks and setting squares together on the diagonal.

Borders

Measure the quilt through the center from top to bottom. Add 8 inches to that measurement. Because the borders are mitered, you will need the extra length. Sew enough 2" pink strips together to equal that measurement. Repeat with the 2" white strips. Make two white border strips and two pink border strips.

Sew a white border strip to a pink border strip. Press toward the darker fabric. Make two, one for each side of the quilt. Fold each border in half lengthwise, and mark the halfway point. Line up the mark with the center point on the side of the quilt. As you sew each border strip to the sides of the quilt, start and stop 1/4" from the end of the quilt.

Repeat the same process, and make a border strip for the top and one for the bottom of the quilt. Sew in place.

To miter each corner, place one border strip over the other. Align the edge of a 90-degree right triangle with the raw edge of the top strip. The triangle's long edge will intersect the border seam in the corner. On the reverse side of the border strip, draw along the triangle edge from the seam out to the raw edge.

Repeat the marking process by putting the bottom border strip on top. With right sides facing, match up the marked seam lines and pin. Begin at the inside corner and sew the strips together, stitching exactly on the marked lines. Make sure the corner lies flat, then trim away the excess fabric, leaving 1/4" seam allowance. Press the mitered seam open.

Layer the quilt with backing and batting, and quilt as desired.

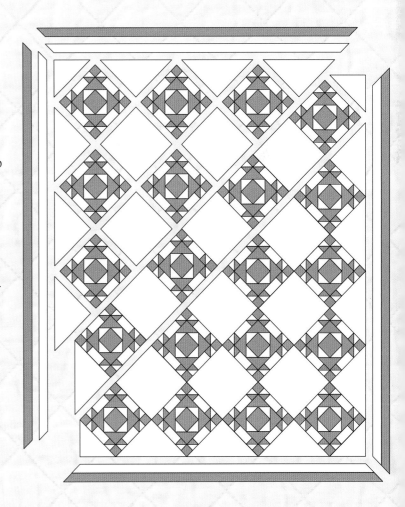

Fiesta Ware

Quilt Size: 60" Square Finished
Block Size: 12" Finished

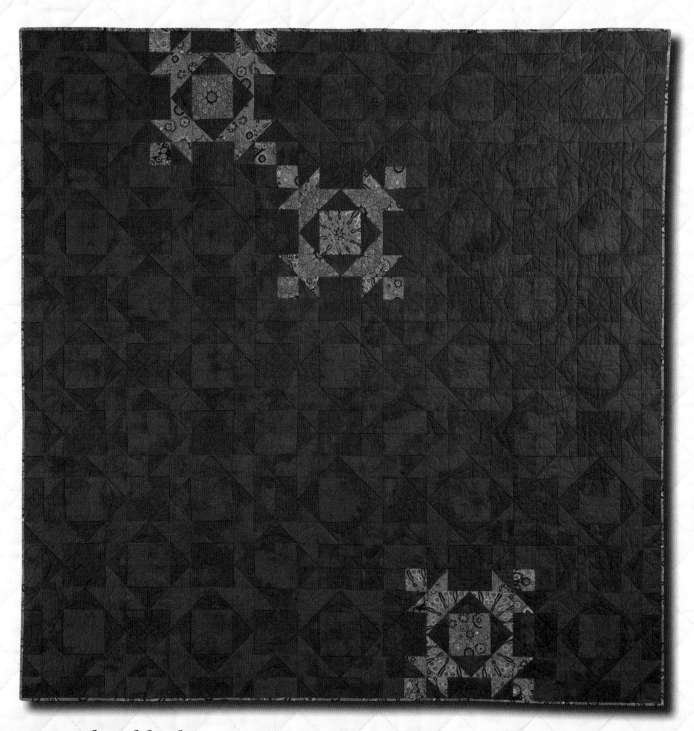

For an updated look, we switched out the soft pinks and whites for bold orange and blues and spiced it up with three blocks using a bright print. We set the blocks together row by row rather than on point and did away with setting blocks. Not only did those little changes alter the appearance, they added glorious movement to the quilt. Quilt stitched by Klonda Holt, Overland Park, Kansas, and quilted by Shelly Pagliai, Wien, Missouri.

Fabric Needed

1/2 yards orange

1/2 yards blue

/2 yard bright orange print

/8 yard for binding

Cutting Instructions

From the orange, cut:

88 – 2 1/2" squares (A)

88 – 2 7/8" squares (B) – Cut each square from corner to
rner once on the diagonal.

44 – 4 7/8" squares (D) – Cut each square from corner to
rner once on the diagonal.

22 – 4 1/2" squares (E)

From the blue fabric, cut:

100 – 2 7/8" squares (B) – Cut each square from corner to
corner once on the diagonal.

100 – 2 1/2" x 4 1/2" rectangles (C)

25 – 5 1/4" squares (F) – Cut each square from corner to
corner twice on the diagonal.

From the bright orange print fabric, cut:

12 – 2 1/2" squares (A)

12 – 2 7/8" squares (B)– Cut each square from
corner to corner once on the diagonal.

6 – 4 7/8" squares (D) – Cut each square from
corner to corner once on the diagonal.

3 – 4 1/2" squares (E)

Follow the directions for making the block on Pages 22 and
23. Make 22 blocks using the orange and blue fabric and 3
blocks using the bright orange print and the blue fabric.

Sew the blocks together into 5 rows of 5 blocks.

Sew the 5 rows together. Layer the top with backing and
batting, and quilt as desired.

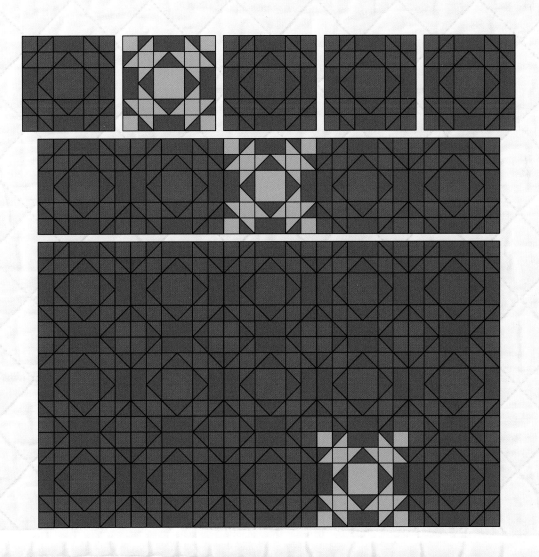

Cedars of Lebanon Quilt and Table Runner

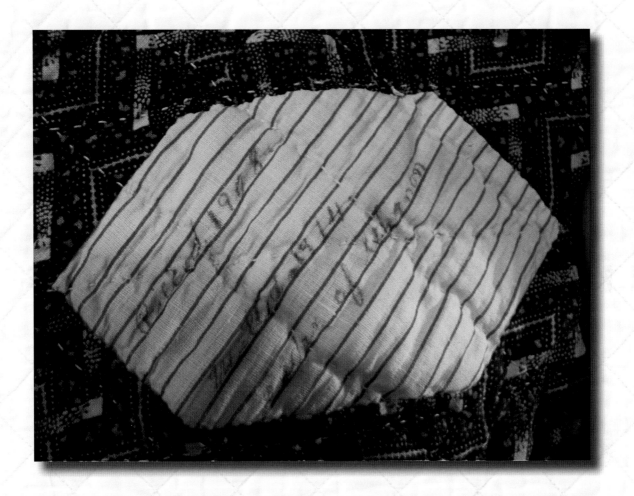

None of the quilts Susan found in the house had been signed. However, she did find this one that was dated. Inscribed in the center in ink are the words, "Pieced 1908 - Quilted 1914 - Cedars of Lebanon."

Cedars of Lebanon

Block Size: 12" Finished

Quilt Size: 79" Square Finished

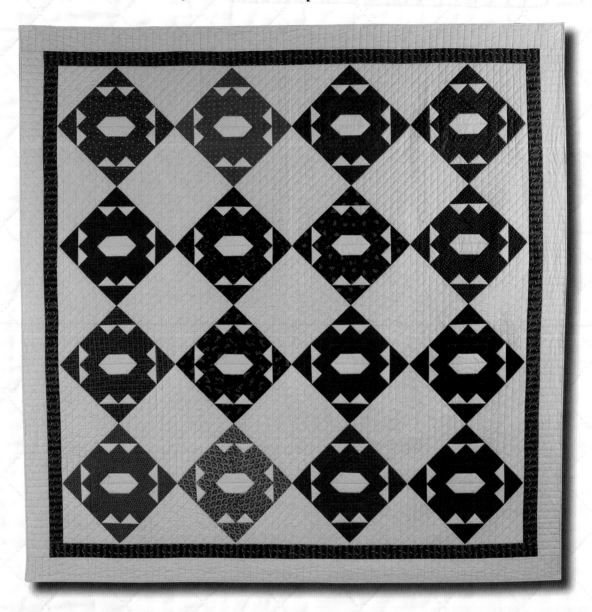

Our reproduction quilt uses the same color palate as the original. We made the binding much narrower and used a narrow framing border to set off the blocks in the center. Stitched by Sandra Amstutz, Bloomfield, Iowa, and quilted by Shelly Pagliai, Wien, Missouri.

Fabric Needed

16 assorted 1/4 yard prints (double pinks, mourning grays, purples, blacks, burgundies, blues)

3/4 yard purple print for framing border

3/4 yard shirting (block centers)

3 1/4 yards gray (setting blocks, setting triangles, corner triangles and borders)

2/3 yard for binding

Cutting Instructions

From each of the assorted prints, cut:

2 – 4 7/8" squares (A) - Cut each square from corner to corner once on the diagonal.

1 – 2 7/8" square (C) – Cut the square from corner to corner once on the diagonal.

4 – 4 1/2" squares (B)

6 – 2 1/2" squares (E)

rom the shirting fabric, cut:

54 – 2 7/8" squares (C) – Cut each square from corner to orner once on the diagonal.

16 – 4 1/2" squares (D)

rom the purple fabric, cut:

3 – 2 1/2" strips across the width of the fabric for the framing order

rom the gray fabric, cut:

9 – 12 1/2" squares

3 – 18 1/4" squares – Cut each square from corner to corner vice on the diagonal to make setting triangles.

2 – 9 3/8" squares – Cut each square from corner to corner nce on the diagonal to make corner setting triangles.

3 – 4" strips across the width of the fabric for outer border

o Make Each Block

ew a shirting C triangle to two sides of a print E square as own.

ew a C/E unit to a print A triangle. Make 4 of these corner its.

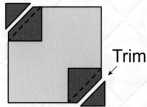

o make the center unit, draw a line from corner to corner ce on the diagonal on the reverse side of two – 2 1/2" print squares. Place an E square atop a shirting D square with right les facing. You need a square on two opposing corners of the piece. Stitch along the drawn lines then trim 1/4" away from e seam lines. Open the unit and press the seams toward the rkest fabric.

Trim

w a corner unit to two sides of a print B square.
lake two rows like this.

w a print B square to either side of the center unit.
ke one row.

Sew the three rows together to complete the block. Make 16.

Putting It All Together

Sew the blocks together on the diagonal, adding in the gray setting squares and the setting triangles as shown in the diagram below.

Once the rows are stitched together, add a corner triangle to each corner.

Measure the quilt top through the center from top to bottom. Sew enough 2 1/2" purple strips together to equal that measurement. Make 2 and sew one to the either side of the quilt top.

Measure the quilt top through the center from side to side. Sew enough 2 1/2" purple strips together to equal that measurement. Make 2 and sew one to the top of the quilt and the other to the bottom.

Measure the quilt top through the center from top to bottom. Sew enough 4" gray strips together to equal that measurement. Make 2 and sew one to either side of the quilt.

Measure the quilt top through the center from side to side. Sew enough 4" gray strips together to equal that measurement. Make 2 and sew one to the top of the quilt and the other to the bottom.

Layer the quilt with backing and batting, and quilt as desired.

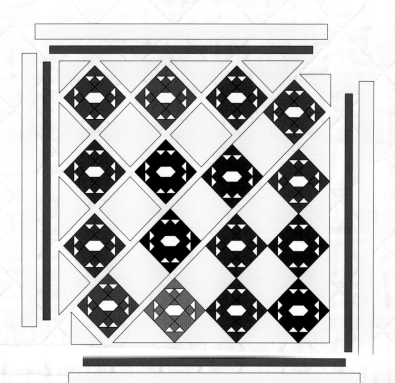

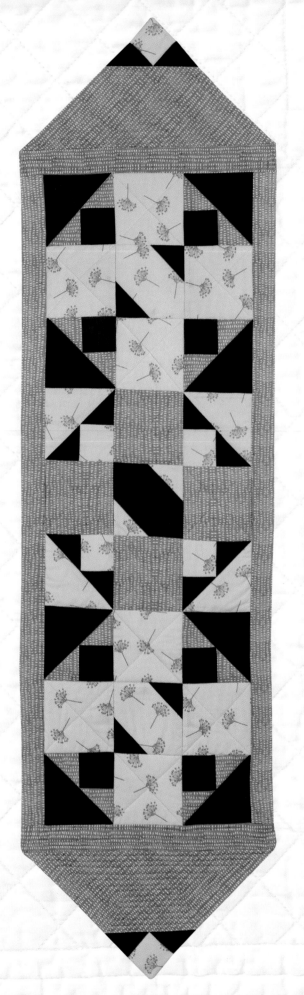

Cedars of Lebanon
Table Runner

Block Size: 12" Finished

Table Runner: 14 1/4" x 52 1/2" Finished

We brightened things up and changed the co[...] or placement in the block. For this project, we used three color[...] instead of two. We've also added a shortcut when it comes to making those triangular corner units. Table Runner stitched an[...] quilted by Edie McGinnis, Kansas City, Missouri.

Quick and Easy Corner Units

Using this method, you will be able to make two corner units quickly and accurately.

Cut two 2 1/2" squares and two 2 1/2" x 3 1/2" rectangles. Sew a 2 1/2" square to one end of each rectangle. Press the seam allowance toward the rectangle. Sew the two together with right sides facing. The squares will be on opposite ends when you stitch them together. Note: No matter what size you wish to make these units, the rectangle is always the same width as the square, and the length is always the size of the square plus 1".

Turn the unit over, and clip the seam almost to the stitching line. You should be clipping about halfway between the two squares. Use a spritz or two of Mary Ellen's Best Press, and press the seam allowances toward the rectangles.

Line up a ruler so it crosses directly over the seam allowance. Using a pencil, draw a line across each seam allowance, making sure the line ends at the corner of the rectangle.

Cut another rectangle that measures the same size as the pieced unit (in this case, 4 1/2" x 5 1/2"). With right sides facing, pin the two units together, and sew directly on the drawn lines.

Place the quarter-inch mark on the ruler on the drawn line. Cut the units apart using a rotary cutter.

Open the two units, and press the seam allowance toward the larger triangle.

Note: This works great when you're making triple triangles, too. Just replace the square with a half-square triangle unit.

Fabric Needed

1 fat quarter yellow

1 fat quarter black

1 3/4 yards gray – includes backing

Cutting Instructions

From the yellow fabric, cut:

2 – 4 7/8" squares (A) – Cut the squares from corner to corner once on the diagonal.

8 – 4 1/2" squares (B)

2 – 4 1/2" squares (D)

8 – 2 1/2" squares (E)

From the black fabric, cut:

4 – 4 7/8" squares (A) – Cut the squares from corner to corner once on the diagonal.

6 – 2 7/8" squares (C) – Cut the squares from corner to corner once on the diagonal.

1 – 4 1/2" square (D)

12 – 2 1/2" squares (E)

From the gray fabric, cut:

4 – 4 1/2" squares (B)

8 – 2 7/8" squares (C) – Cut the squares from corner to corner once on the diagonal.

1 – 10 1/2" square (end triangles) – Cut the square from corner to corner once on the diagonal.

3 – 1 1/2" across the width of fabric - border

1 – 14 1/2" x 52 1/2" rectangle - backing

To Make Each Block

Follow the directions on Page 29. Refer to the photo for color placement. You'll have two blocks that have yellow in the B squares and one block that has gray in the B squares.

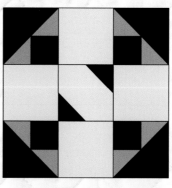

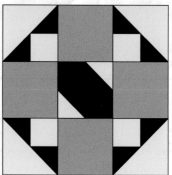

When the three blocks are complete, sew them together. Refer to the photo, if necessary.

Measure the length of the runner through the center from top to bottom. Trim two 1 1/2" gray strips to equal that measurement. Sew one to each side of the runner.

Measure the length of the runner through the center from side to side. Trim two 1 1/2" gray strips to equal that measurement. Sew one to each end of the runner.

dd a gray end triangle to the top and bottom of the runner.

ew a black C triangle to two sides of a yellow E square.
ake two.

Measure 3" up from the point of the end triangle, and mark a
e across the end. Place a black and yellow C/E unit at that
int, with right sides facing.

titch the unit in place, and trim off the point of the gray
angle. Repeat for the remaining end.

lace the table runner on the backing fabric with right sides
cing. Place a piece of batting on the reverse side of the
cking, and sew through all three layers, leaving a 3" opening
ong one side. This will enable you to turn the table runner
ght side out.

rim all excess batting away from the sewn line. Turn right
le out, and whipstitch the opening closed.

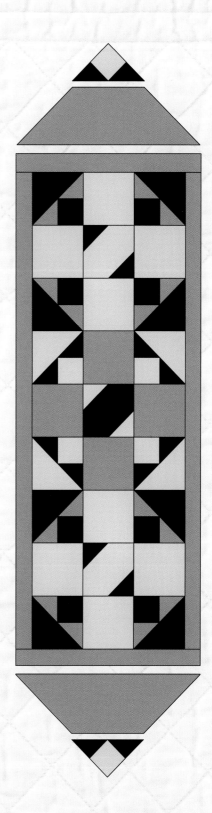

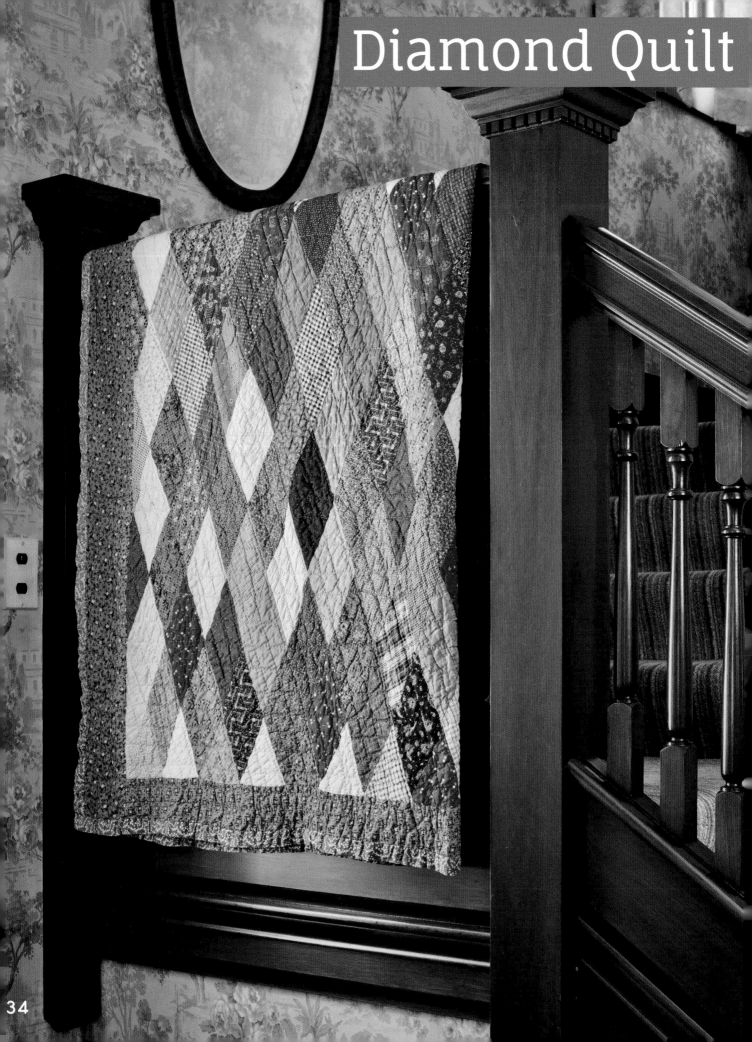

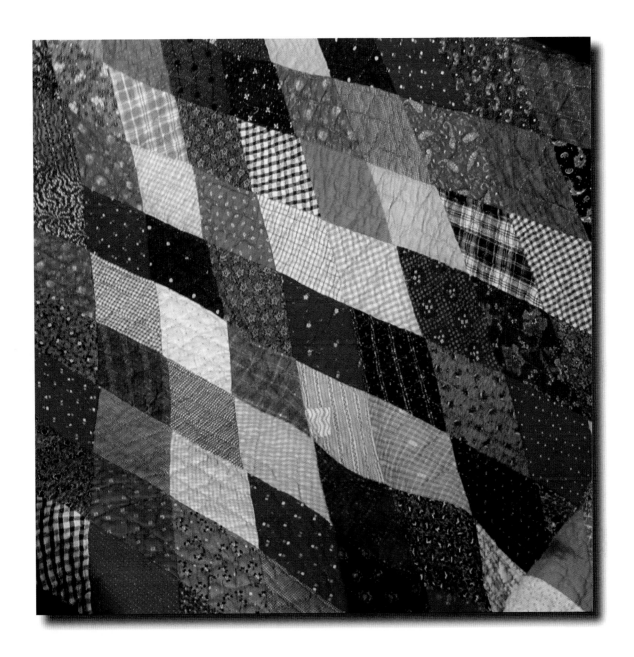

The blues, grays, reds, shirtings and pinks have faded and softened the look of this lovely old quilt. I can't help but wonder how many evenings were spent cutting the diamonds, marking them and stitching them together.

Diamond Quilt

Quilt Size: 81" x 87" Finished

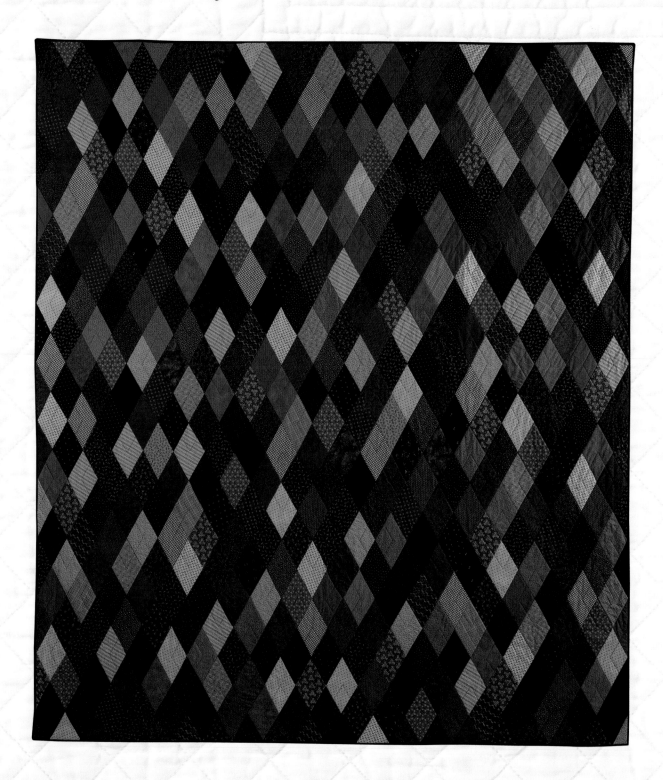

This is a bit larger than the original quilt and more in keeping with quilts made today. Even though we used reproduction fabrics, our quilt turned out darker than the original. We did away with the border and used a narrow binding. Stitched by Sandra Amstutz, Bloomfield, Iowa, and quilted by Shelly Pagliai, Wien, Missouri.

Fabric Needed

41 fat quarters of various prints – We used reproduction fabrics that reflect the early 1900s.

3/4 yard fabric of your choice for binding

Cutting Instructions

From each of the fat quarters, cut 4 1/8" strips across the width of each fat quarter. Cut the strips into 60 degree diamonds using template A.

To make fast work of cutting many diamonds, layer four strips, one atop the other with the edges aligned, with right sides facing up.

Place template A on the strips. Butt a rotary cutting ruler up against the edge of the left side of the template. Pull the template away, and make your first cut.

Turn the strips around and place the template back on the strips with the template aligned with the cut edge, butt the ruler up against the left edge of the template, pull the template away and make the next cut.

Continue in this manner until you have all of your diamonds cut. You will need 488 diamonds.

After cutting the diamonds, lay them out until you're pleased with the color combination. Refer to the picture to get a sense of color placement.

The diamonds are sewn together on the diagonal. When sewing them together, offset each piece by 1/4". See the diagram below.

Pin in place and sew, but be gentle. You are working with bias edges, so you don't want to pull and distort the pieces.

Follow the chart below and sew the rows together on the diagonal. Press all seam allowances going in the same direction every other row. Reverse the direction in the others.

After sewing all the rows together, square up the corners and trim off the points, leaving a 1/4" seam allowance all the way around. Layer the quilt with backing and batting, and quilt as desired.

Wow! Diamonds!

Quilt Size: 56" x 59" Finished

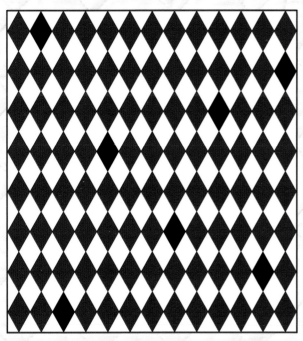

Digital image.

From the black fabric, cut:

7 diamonds using template A

To make this version of our quilt, follow the piecing directions on Page 37.

Sew the diamonds together on the diagonal. Refer to the instructions on Page 37. Notice that the color placement is not random. Instead, the colors alternate, so follow the chart below for color placement. Sew the rows together on the diagonal. Press all seam allowances going in the same direction every other row. Reverse the direction in the others.

After sewing all the rows together, square up the corners and trim off the points, leaving a 1/4" seam allowance all the way around.

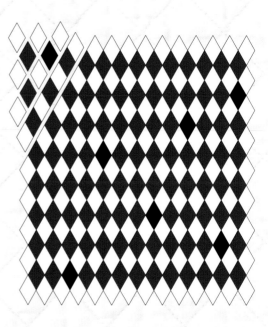

Layer the quilt with binding and backing. Quilt as desired.

It's easy to update the look of the Diamond quilt by changing the fabric to classic red and white. Toss in a few pieces of black to add interest and movement, and you suddenly have a quilt that's loaded with the "wow" factor.

Fabric Needed

2 yards red
2 1/4 yards white
1/8 yard black
5/8 yard for binding

Cutting Instructions

(Refer to the instructions on Page 37 for cutting multiple diamonds from strips.)

From the red fabric, cut:

97 diamonds using template A

From the white fabric, cut:

126 diamonds using template A

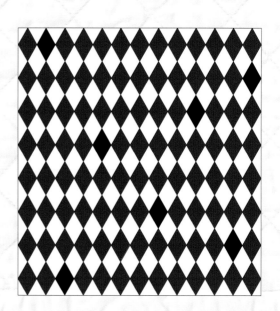

A

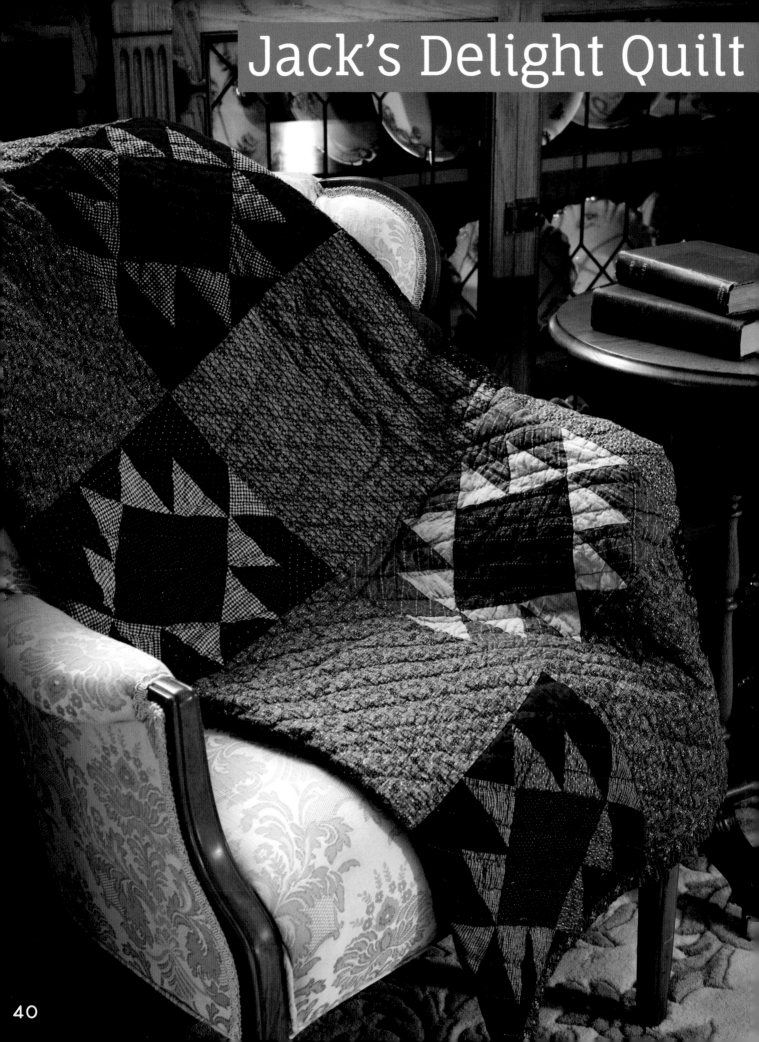

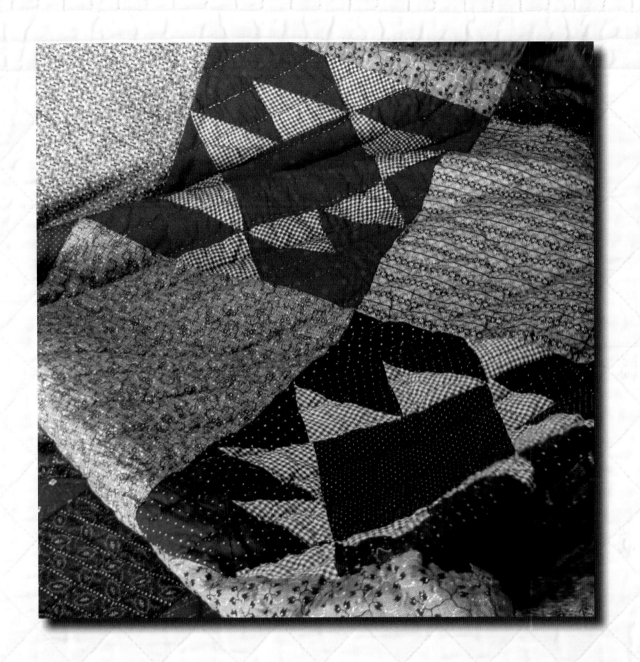

Large setting squares of mourning blacks and grays were used to set the quilt together. It looks as though this quilt was never used, because the colors are bright and unfaded.

Jack's Delight

Quilt Size: 34 1/4" x 34 1/4" Finished

Block Size: 9" Finished

Instead of using varied colors in our quilt, we combined classic shirtings and indigos. We also eliminated the alternating squares so we could admire the secondary pattern that emerges when the blocks are touching. Stitched and quilted by Edie McGinnis, Kansas City, Missouri.

Fabric Needed

1 1/2 yards indigo (There were four different prints used.)

1 yard shirting (We used three different prints.)

1/3 yard for binding

Cutting Instructions

For each block, cut the following pieces:

From the indigo, cut:

2 – 3 7/8" squares (A) – Cut the squares from corner to corner once on the diagonal.

3 – 4 1/4" squares (B) – Cut the squares from corner to corner twice on the diagonal.

1 – 4 3/4" square (C)

From the shirting fabric, cut:

3 – 4 1/4" squares (B) – Cut the squares from corner to corner twice on the diagonal.

Borders

From the shirting, cut:

8 – 3" squares – Cut the squares from corner to corner once on the diagonal.

4 – 2" strips across the width of the fabric for the inner bord

From the indigo, cut:

2 – 2 5/8" squares

3 –3" squares – Cut the squares from corner to corner once on the diagonal.

4 – 2 5/8" strips across the width of the fabric for the outer border

You might want to wait until your blocks are sewn together before you cut your border strips. It's always a good idea to measure vertically and horizontally through the center of the quilt to get an exact measurement.

To Make Each Block

Sew an indigo B triangle to a shirting B triangle. Make 8.

Pair up two B units, and sew them together. Make 2 sets, and sew them to opposing sides of the center C square.

Pair up two more B units, and sew them together. Make 2 sets. Add a shirting B triangle to one end and an indigo B triangle to the other end.

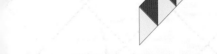

Sew the strips to opposing sides of the center square.

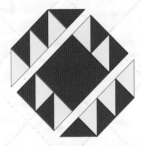

Add an indigo A triangle to each corner to complete the block. Make 9.

Sew three blocks together to make a row. Make 3 rows.

Sew the rows together to complete the center of the quilt.

Measure the length of the quilt through the center from top to bottom. Trim two 2" white strips to equal that measurement.

Sew one to each side of the quilt.

Measure the width of the quilt through the center from side to side. Trim two 2" white strips to equal that measurement. Sew one to the top of the quilt top and one to the bottom.

Pair up a shirting 3" triangle with an indigo 3" triangle. Make 16.

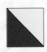

Sew three half-square triangle units together, then add an indigo 2 5/8" strip. Measure the length of the quilt through the center from top to bottom. Trim the indigo end of the strip so the entire strip is equal to that measurement. Make 2.

Refer to the diagram for placement of half-square triangles and sew one to each side of the quilt.

Sew a strip of five half-square triangles together. Add an indigo 2 5/8" square to one end and an indigo 2 5/8" strip to the other. Measure the width of the quilt through the center from side to side. Trim the indigo strip end so the entire strip is equal to that measurement. Make 2.

Refer to the diagram for placement of half-square triangles and sew one to the quilt top and one to the bottom. Layer the quilt with backing and batting, and quilt as desired.

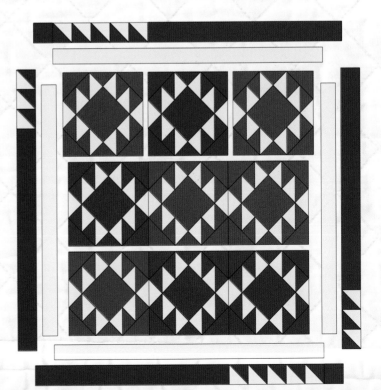

Jack's Delight Pillow

Pillow Size: 13 1/2" x 13 1/2" Finished

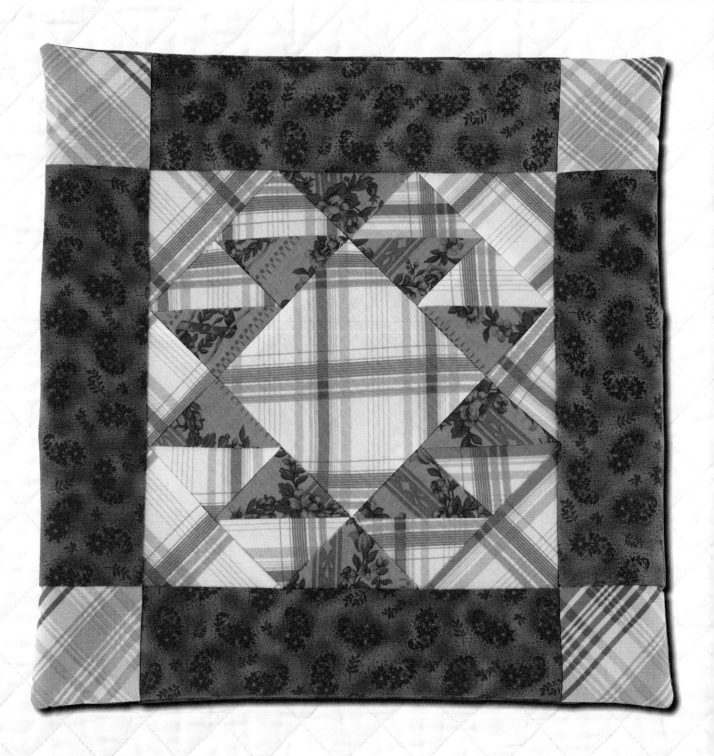

We traded Jack's Delight's more somber hues of indigo and shirtings for a pretty, cheery pink plaid and two rose prints to come up with this pillow to toss onto a bed or the nearest chair. Stitched by Edie McGinnis, Kansas City, Missouri.

abric Needed

 fat quarter pink and white plaid

 fat quarter medium rose print

/2 yard dark rose print

ther Supplies

 pillow form to fit

Follow the cutting and piecing instruction on Page 43 to
ake one block using the pink plaid as the indigo and the
edium rose print as the shirting.

om the pink plaid, cut:

 – 3" pink plaid squares

om the dark rose print, cut:

 – 3" x 9 1/2" rectangles

 – 8 1/2" x 14" rectangles (pillow back)

ew a dark rose rectangle to two sides of the block.

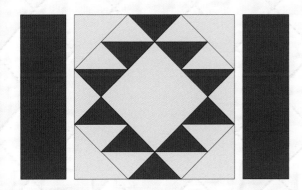

ew a pink plaid 3" square to either end of a dark rose rectan-
. Make 2, and sew one to the top and one to the bottom, as
own.

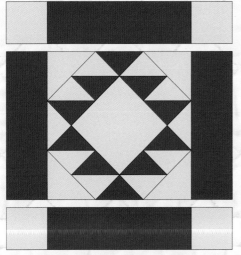

To make the pillow back, turn under 1/4" seam allowance
on the 14" length of the dark rose rectangles, then turn under
another 1/4". Press in place, then stitch across the edge.

Align the raw edges of the rectangles with the front of the
pillow top with right sides facing. The two pieces of the pillow
back will overlap by about 2". Stitch around the outer edge.

Turn the pillow right side out, and insert the pillow form to
complete the project.

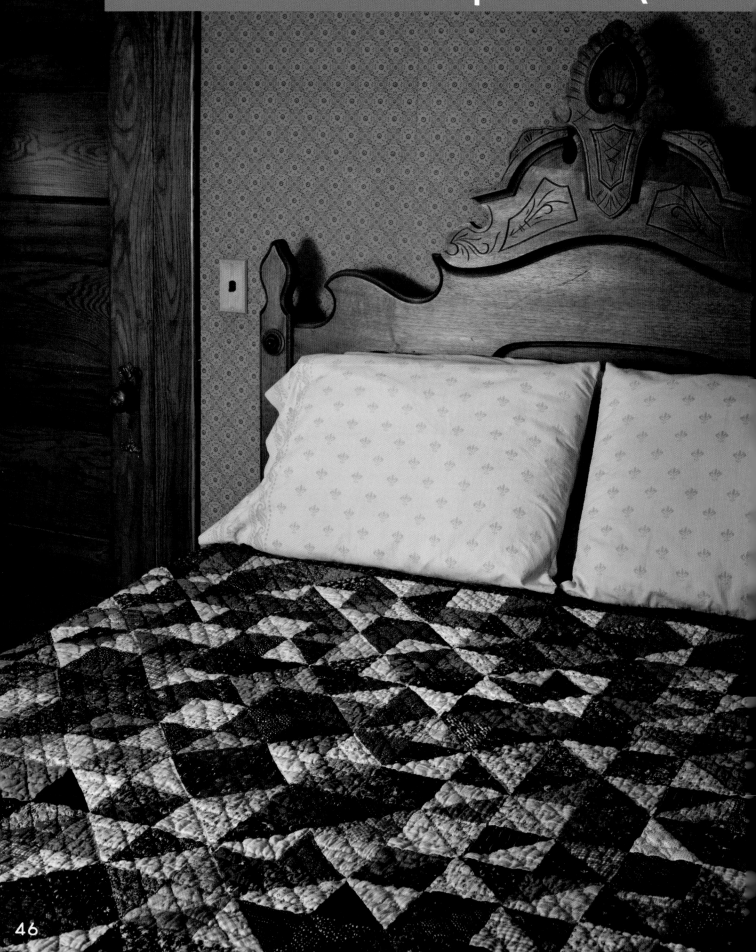

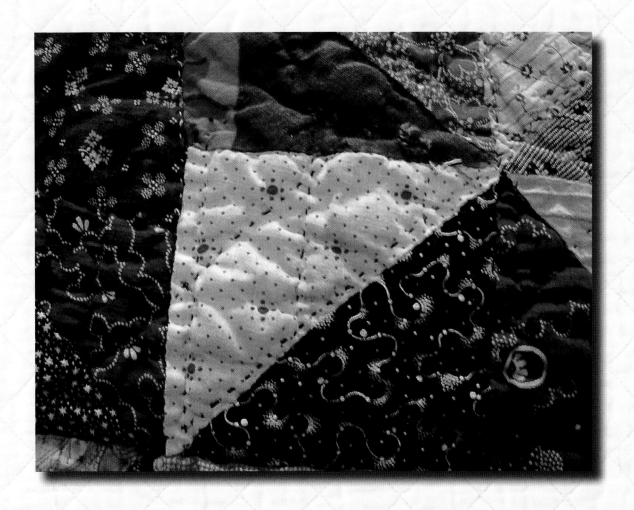

The original quilt found in the house was made using fabric popular in the early 1900s. As you look at the photo of the quilt, you will find a lovely assortment of double pinks, purples, blues, clarets and shirtings.

The Double Square Quilt

Quilt Size: 90" x 96" Finished

Block Size: 6" Finished

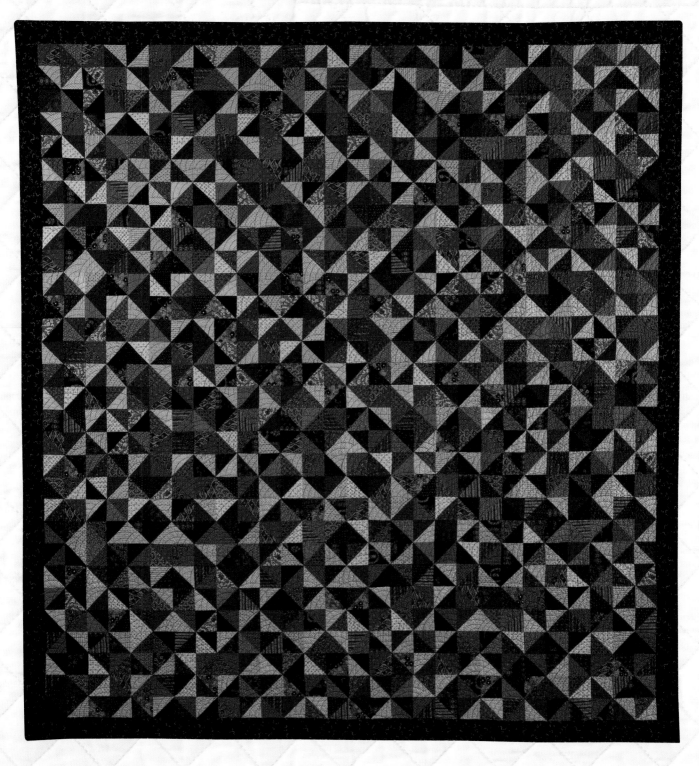

We made our quilt using reproduction fabrics that reflect the early 1900s. Our quilt is finished with a 3" border of a black print that uses neon green as well as tan. Stitched by Sandra Amstutz, Bloomfied, Iowa, and quilted by Shelly Pagliai, Wien, Missouri.

Fabric Needed

21 assorted 1/4 yard light fabric
21 assorted 1/4 yard dark fabrics
1 1/4 yard black print
3/4 yard for binding

Cutting Instructions

From the assorted light fabrics, cut:
420 – 3 7/8" squares

From the assorted dark fabrics, cut:
420 – 3 7/8" squares

From the black print, cut:
10 – 3 1/2" strips across the width of the fabric for border

Draw a line from corner to corner once on the diagonal of the reverse side of the light squares. Layer a light square with a dark square, with right sides facing. Place the lightest square on the top, and sew 1/4" on either side of the drawn line. Cut on the drawn line, and press each of the half-square triangles open with the seam toward the darker fabric. Make 840 half-square triangles.

Half-square triangles can be made any number of ways. You can use Thangles or Triangles on a Roll or you can cut each square from corner to corner, mix up the colors and sew the triangles together along the bias.

To Make the Block

Pair up two half-square triangles, and stitch them together. One half-square triangle should have the lightest triangle sewn to the darkest triangle as shown. Make two.

Sew the two sewn pairs together to complete one block. Make sure the lightest triangles are toward the center. Make 210 blocks.

Sew the blocks together into rows of 14 horizontally. Make 15 rows.

Sew the rows together to complete the center of the quilt.

Borders

Measure the quilt top through the center from top to bottom. Sew enough 3 1/2" black print strips together to equal that measurement. Make 2. Sew one to each side of the quilt top.

Measure the quilt top through the center from side to side. Sew enough 3 1/2" black print strips together to equal that measurement. Make 2, Sew one to the top of the quilt top and one to the bottom.

Layer the quilt with batting and backing, and quilt as desired.

Double Square Wall Hanging

Quilt Size: 36" x 36" Finished
Block Size: 6" Finished

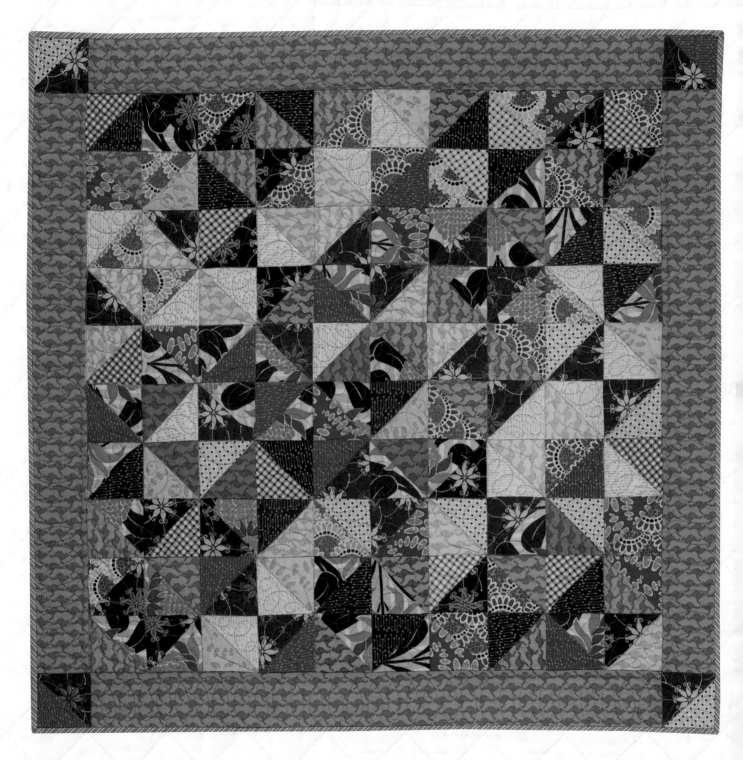

We made this stunning little wall quilt using the fabric line Terra Australis by Ella Blue. Sweet tone-on-tone kangaroos hop through the quilt in bright lime green, orange, pink and blue. Stitched and quilted by Edie McGinnis, Kansas City, Missouri.

Fabric Needed

8 assorted fat quarters
1/2 yard border fabric
1/3 yard for binding

Cutting Instructions

From the assorted fat quarters, cut:

104 – 3 7/8" squares

From the border fabric, cut:

4 – 3 1/2" strips across the width of the fabric

To Make the Quilt

Follow the instructions on Page 49, and make 104 half-square triangles. Set 4 aside for the border. Use the remaining 100 half-square triangles to make 25 blocks. Sew the blocks together into rows of five. Make five rows and sew the rows together.

Borders

Measure the quilt top through the center. Trim the 4 – 3 1/2" border strips to equal that measurement. Sew one to each side of the quilt top.

Make four 3" finished half-square triangles. The instructions are on Page 49.

Sew a reserved half-square triangle to either end of the remaining two border strips. Sew one to the top of the quilt and one to the bottom.

Layer the quilt with batting and backing, and quilt as desired.

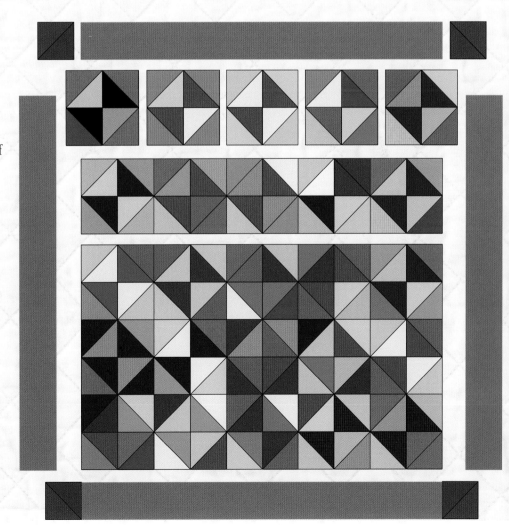

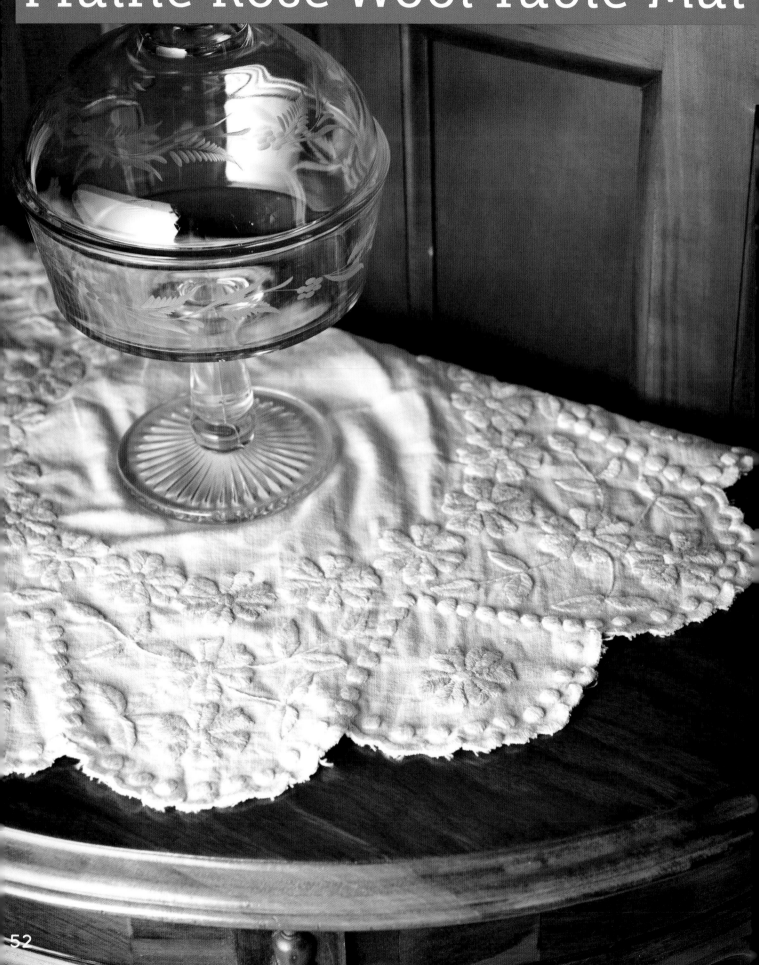

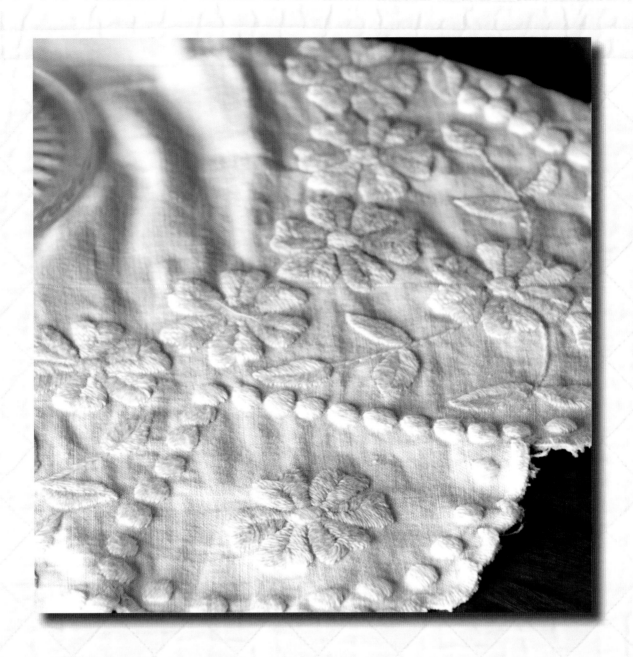

Susan found more than quilts in the house. Linens had been tossed on an old mattress and left behind. Among the linens was the table topper you see here. It had been hand-embroidered, and the edges had been finished with a tiny white blanket stitch. A padded satin stitch separated the segments and enhanced the outer edge. The pink and white flowers remind me of the wild prairie rose, the state flower of Iowa.

Prairie Rose Wool Table Mat

Size: 22" Finished

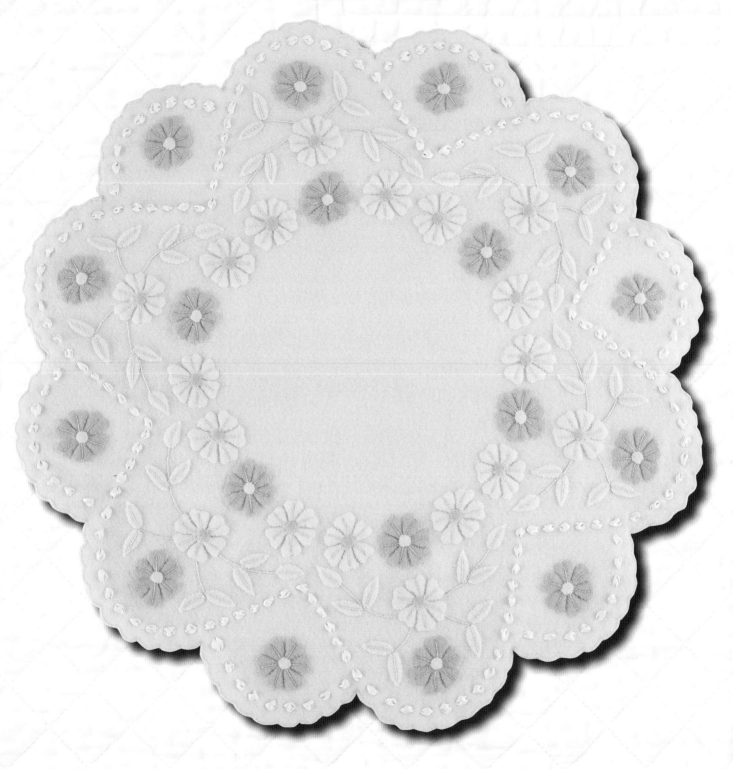

After seeing the linen table mat, I decided not to reproduce it in this book. I began working on the quilts, but visions of the table mat kept popping into my head. I kept thinking how pretty it would be if the flowers were cut from wool and appliquéd onto a wool background. Robin Sackett of Custom Handwork Liberty, Missouri, did a beautiful job stitching the piece.

Fabric Needed

2/3 yard 60" wide cream felted wool

1/8 yard pink felted wool

Other Supplies

1 skein DMC pink embroidery floss #225

4 skeins DMC white embroidery floss # 712

7 yards 3/8" white silk ribbon

Cutting Instructions

From the cream wool, cut:

12 leaves using the template marked Leaf A

48 leaves using the template marked Leaf B

18 white flowers

18 white circles for flower centers

2 – 24" background pieces – use the template provided

From the pink wool, cut:

18 pink flowers

18 pink circles for flower centers

To Make the Table Mat

Trace the pattern for the mat onto freezer paper. You will notice that you have to join two pieces while tracing. Align the dotted lines when joining the two. The pattern given is for two scallops, and you need 12.

Mark the edge of the scallops onto the background piece. You might want to wait to trim the edges until after the appliqué and embroidery work is complete.

Mark the placement of the ribbon next, indicated on the pattern by circles that have a line drawn through the center. Refer to the photo, if necessary.

You can now see where to place the flowers and the leaves. After placing the leaves and flowers onto the background, appliqué them in place using a whipstitch and one strand of floss.

Embroider the center of the line of the leaves and the stems going from the flower petals to the leaves with three strands of white floss.

Embroider the flower petals using the stem stitch and two strands of floss.

After the embroidery and appliqué work has been completed, thread a large-eye needle with silk ribbon. Gently pull it through the wool using a running stitch.

Layer the top of the project with the second background piece, and trim the scalloped edges.

Sew the two edges together using two strands of cream floss and a buttonhole stitch.

Cut 18 white & 18 pink

Cut 18 white & 18 pink
circles for centers

Leaf B
Cut 48

Leaf A
Top of stem - Cut 12

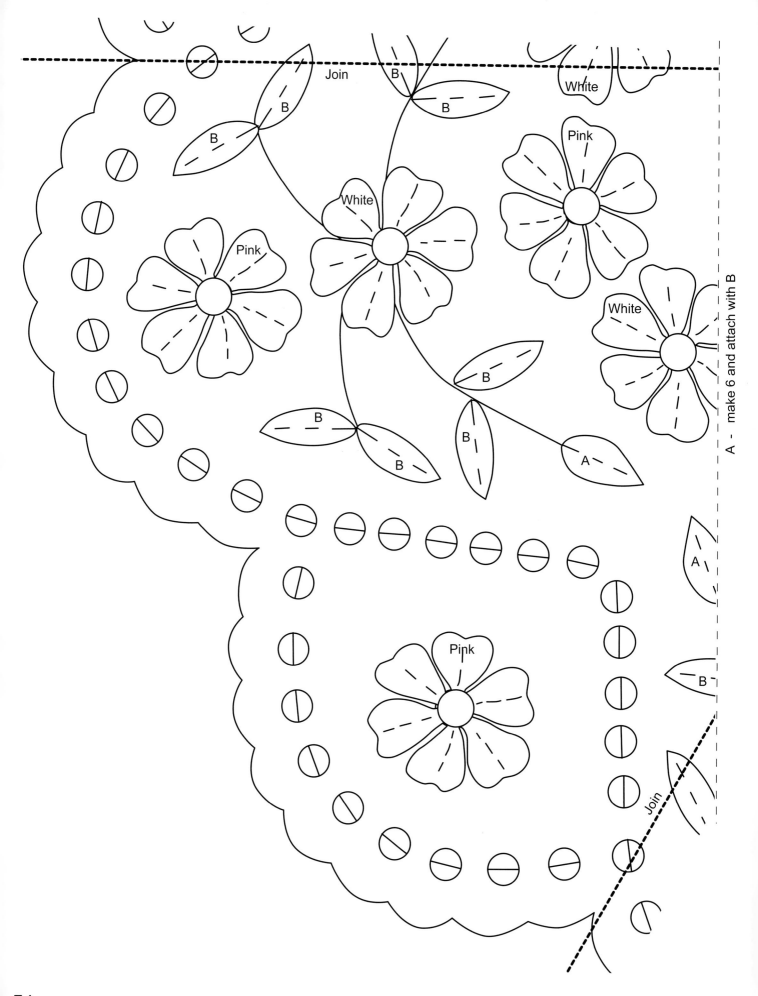

Join

B

B

B

B

White

Pink

White

Pink

B

B

B

B

A

White

A - make 6 and attach with B

A

B

Pink

Join

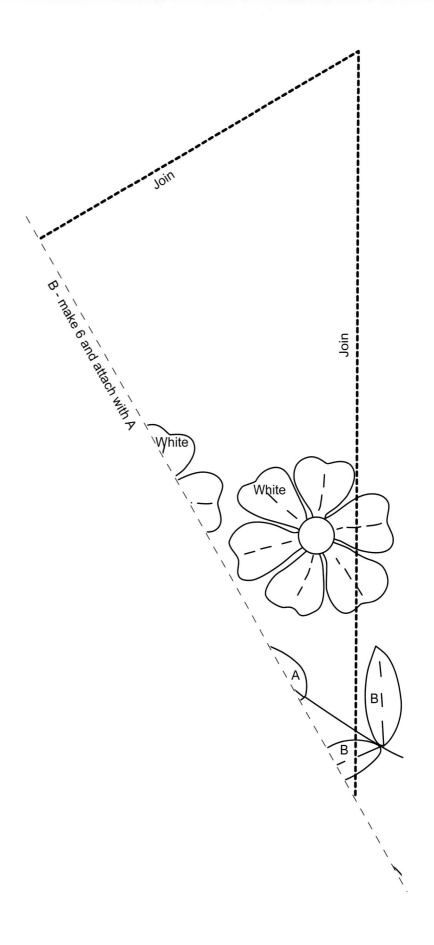

Join

Join

B - make 6 and attach with A

White

White

A

B

B

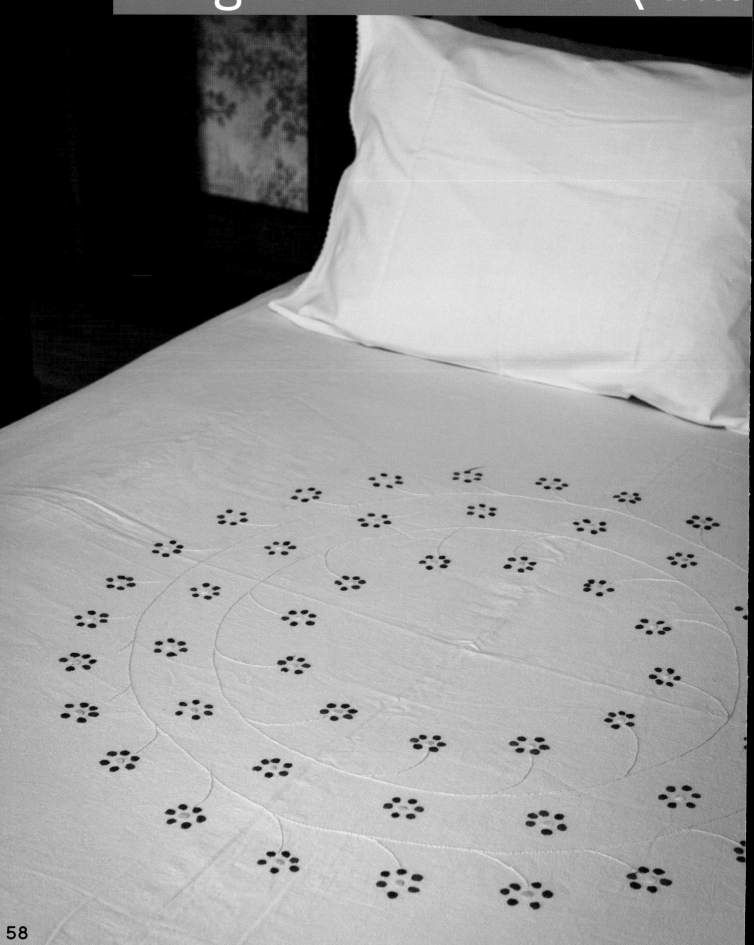

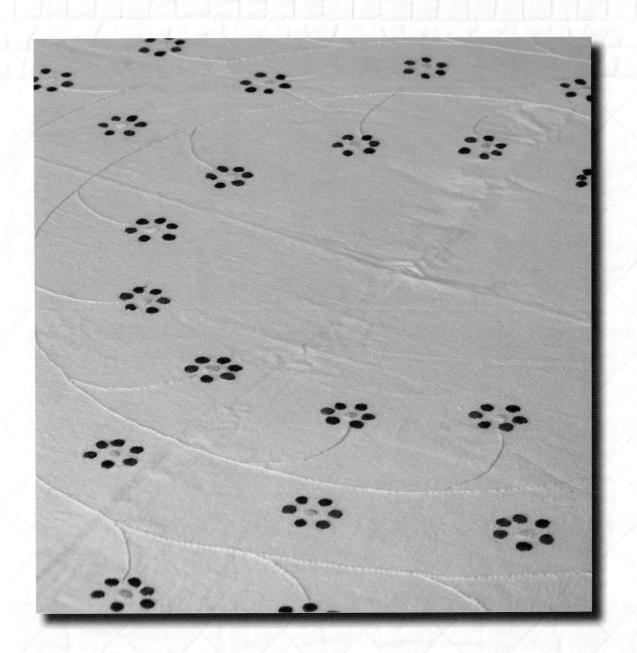

This red and white embroidered summer spread was found in the house. The spread is one layer and has no backing or batting and would have been used in warm weather. The workmanship on the original piece is exquisite, and each corner was mitered perfectly.

Ring of Wild Roses

Quilt Size: 75" x 90" Finished

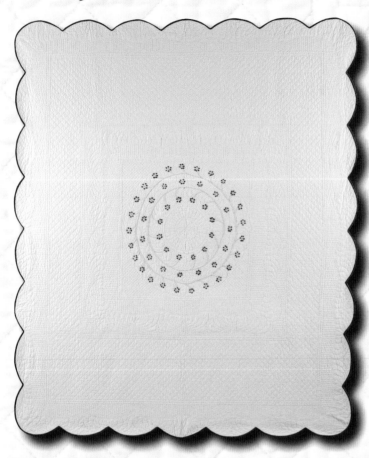

I loved the look of the embroidered spread and thought it might make a wonderful quilt. I did the embroidery by hand while watching television. Stitched by Edie McGinnis, Kansas City, Missouri, and quilted by Shelly Pagliai, Wien, Missouri.

Fabric Needed
3 yards 108" wide cotton sateen
3/4 yard red for binding

Other Supplies
No. 5 Pearl Cotton thread
2 skeins red - DMC #347
1 skein green – DMC #3072
1 skein blue – DMC #927
Embroidery hoop

Fold the fabric in half vertically, then fold again horizontally. Lightly press the creases of the folds. Lightly mark the center point.

Trace the pattern found on Pages 61 and 62 onto freezer paper. The pattern given is for one-fourth of the center medallion. Unfold the lightly-creased cotton sateen fabric, and slip the freezer paper pattern under it. You should be able to see through the fabric.

Trace the pattern onto the fabric using a washout marker. After you trace the first quarter of the medallion, move the pattern to the next quarter, and match the center point. Make sure your circle continues on smoothly. Continue marking until you have completed the center circular medallion.

Embroider the flowers with a satin stitch using the red pearl cotton. Satin stitch the flower centers using the blue floss. The circle and stems should be embroidered using a stem stitch with the green floss.

After the embroidery work is complete, trace the scallops onto freezer paper. Measure out 36" from the center point on both sides horizontally. Position the dip in the scallop at the 36" point.

Stem stitch Satin stitch

Measure 45" from the center point on both the top and the bottom vertically. Position the center of the longest point of the scallop at that mark on the top and the bottom of the quilt.

Trace the scallops onto freezer paper. You should have five scallops between each corner scallop horizontally and six scallops between each corner vertically. If you would like to have your quilt finish larger than the size given, adjust the scallops accordingly.

Mark the scalloped edges onto the quilt top. Do not trim out the scallops until after the quilt is quilted.

After the quilting is finished, trim the edges and bind with narrow red bias binding. I cut 2" strips on the bias, folded it, and sewed it to the front of the quilt using a 1/4" seam allowance. I whipstitched the binding to the back.

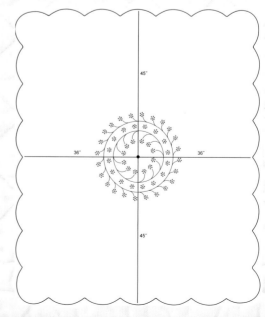

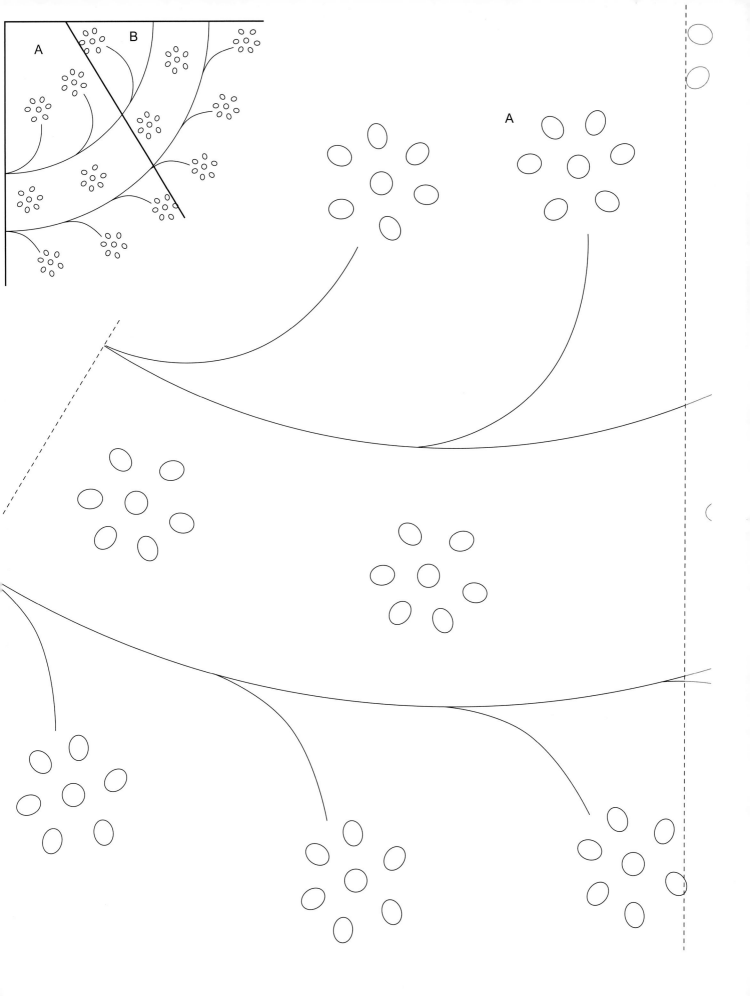

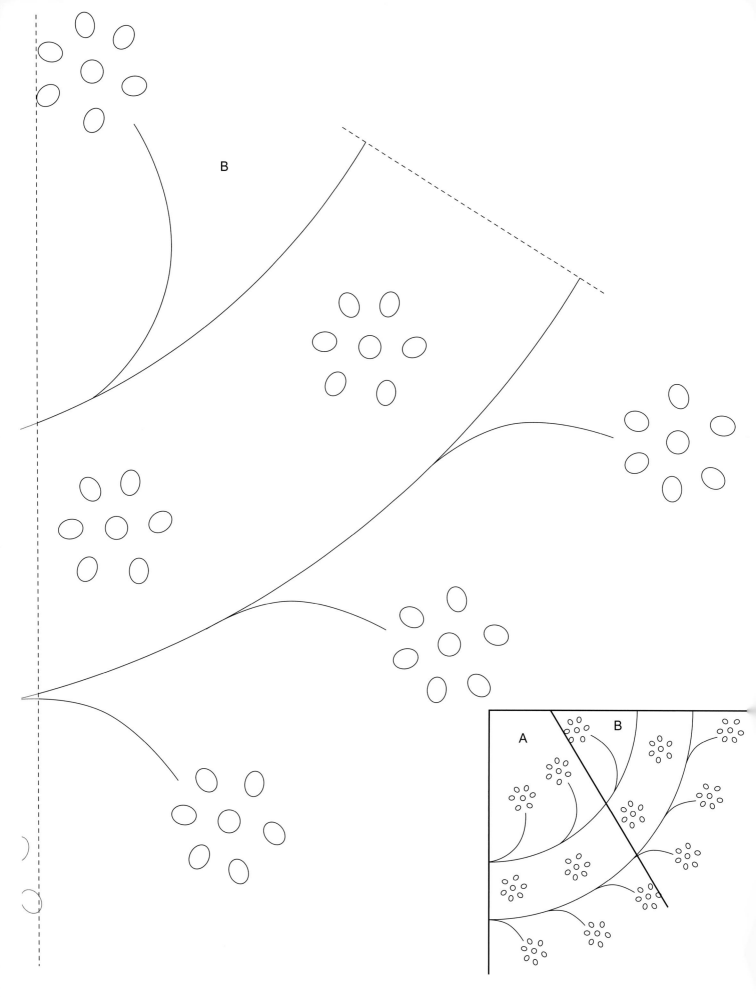

B

A B

62

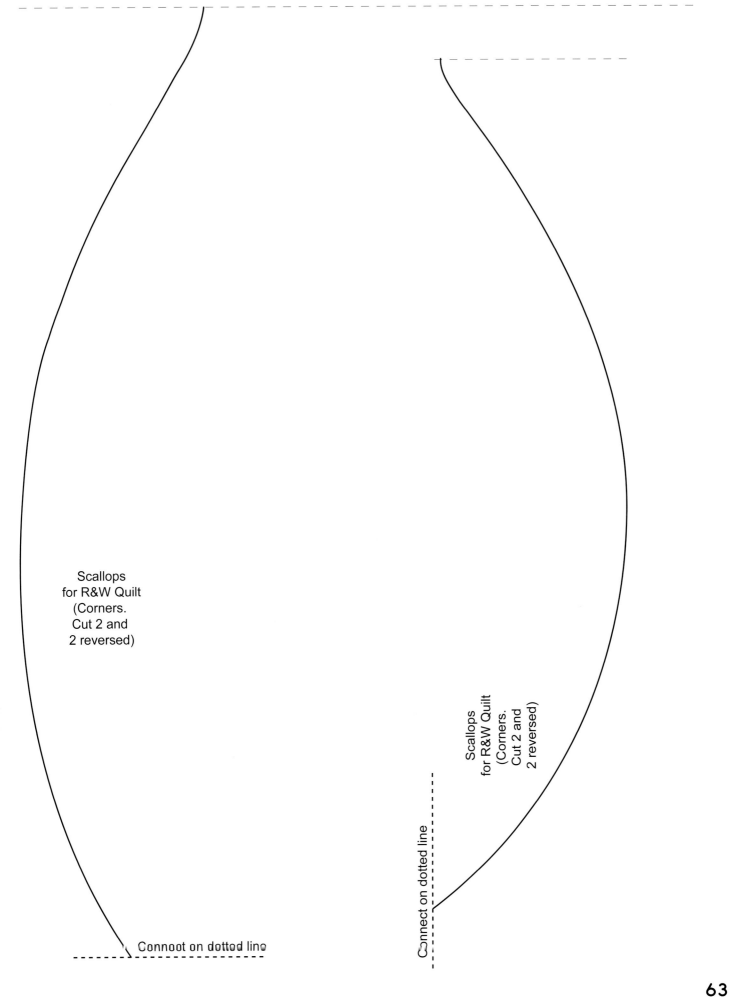

Scallops
for R&W Quilt
(Corners.
Cut 2 and
2 reversed)

Scallops
for R&W Quilt
(Corners.
Cut 2 and
2 reversed)

Connect on dotted line

Connect on dotted line

Connect on
dotted line
to scallops
& corners

Scallops
for R&W Quilt
(Sides)

Connect on
dotted line
to scallops
& corners